THE VENETIAN TWINS
MIRANDOLINA

for Sydney and Jaya Bolt

Goldoni
THE VENETIAN TWINS
MIRANDOLINA

Translated by Ranjit Bolt

OBERON BOOKS
LONDON

First published in these translations in 1993 by Absolute Press
Reprinted in 1997 and 2003 by Oberon Books Ltd.
(incorporating Absolute Classics)
521 Caledonian Road, London N7 9RH
Tel: 020 7607 3637 / Fax: 020 7607 3629
e-mail: oberon.books@btinternet.com
www.oberonbooks.com

Translation copyright © Ranjit Bolt 1993

Ranjit Bolt is hereby identified as author of these translations in accordance with section 77 of the Copyright, Designs and Patents Act 1988. The author has asserted his moral rights.

All rights whatsoever in this play are strictly reserved and application for performance etc. should be made before commencement of rehearsal to The Agency (London) Ltd, 24 Pottery Lane, London W11 4LZ. No performance may be given unless a licence has been obtained, and no alterations may be made in the title or the text of the play without the author's prior written consent.

This book is sold subject to the condition that it shall not by way of trade or otherwise be circulated without the publisher's consent in any form of binding or cover or circulated electronically other than that in which it is published and without a similar condition including this condition being imposed on any subsequent purchaser.

A catalogue record for this book is available from the British Library.

ISBN: 0 948230 63 0

Cover design: Andrzej Klimowski

Printed in Great Britain by Antony Rowe Ltd, Chippenham.

Contents

Introduction, 7

THE VENETIAN TWINS, 9

MIRANDOLINA, 85

Introduction

Carlo Goldoni was born in Venice in 1707. From his earliest years he was drawn to the theatre. His grandfather, who held a lucrative post in the Venetian Chamber of Commerce, was passionately fond of plays, and the young Carlo would have seen private performances at his home outside Venice. At the age of eleven, Goldoni wrote a comedy of his own. His father was so pleased with it that he resolved to give his precocious son the best education money could buy. Carlo was sent to school in Rimini. While still at school there he fell in with a group of strolling players and ran away with them. His indulgent parents then sent him to the Papal College at Pavia, where he was to study jurisprudence. While waiting to begin his studies there, in the library of one of his professors, Goldoni became acquainted with the classic dramas of France and Spain and, in particular, with Molière. He was struck by the absence of Italian plays and decided to remedy the situation.

The seeds of the *riforma* had been sown. This was Goldoni's programme to revitalise Italian theatre, then dominated by the increasingly lifeless *commedia dell'arte*. This genre employed no written dialogue, but only short scenarios. It consisted of little more than a series of improvised scenes based on stock characters and situations. Goldoni's task was to persuade the *commedia* players to set aside their masks and learn written parts. His initial attempts met with mixed results, but *I Due Gemelli Veneziani* (*The Venetian Twins*), which had its premiere in Venice in 1748, enjoyed a success unprecedented in the history of Italian theatre. The writing was on the wall for the *commedia*.

The Venetian Twins, then, constitutes the *riforma's* real success. As in Moliere's comedies, the *commedia* makes its presence felt, but there is also a certain amount of psychological insight and social comment. Take, for example, the scene between Rosaura and Pancrazio at the start of the play, where Rosaura clearly sees Pancrazio as a father

substitute; or that between Tonino and Rosaura, where he thinks she is a prostitute but is nevertheless ready to fall in love with her, if not place her on a pedestal – an early example of the madonna/whore syndrome?

As for social comment, there are several instances of women being treated as second class citizens – property, in effect – to be disposed of by men as they think fit. When Tonino finds Lelio and Florindo wooing Beatrice, he whisks her away, declaring: 'This lady belongs to me.' Again, at the end of the play, Rosaura is summarily married off for no better reason than that her father stands to lose a substantial inheritance.

Mirandolina (*La Locandiera*), written in 1753, is probably the crowning achievement of the *riforma*. Here the psychological and social insight found in embryo in *The Venetian Twins* are far more fully developed. This is particularly true of the almost sado-masochistic relationship between Mirandolina and Ripafratta – a classic study of its kind. There is also some shrewd social comment in Goldoni's portrayals of the Marquess of Forlipopli and the two actresses, Ortensia and Dejanira. All three, though to some extent stock characters, are also convincing examples of snobbery and social pretension. And in his sympathetic portrayal of Mirandolina -the female innkeeper asserting her independence (both sexual and social) over her inadequate male clientele – one can't help thinking that Goldoni is striking an early blow for feminism. With Mirandolina, he can truly be said to have freed Italian theatre from the shackles of a sterile and outmoded form.

Voltaire may have been going a little far when he described Goldoni as the Italian Molière, but there is no doubt that he merited the same critic's appellation of: *'Peintre et fils de la nature'*.

<div style="text-align:right">RB, 1993</div>

THE VENETIAN TWINS

Characters

ROSAURA
Dr Balanzoni's daughter

COLUMBINA
her maid

DR BALANZONI

BRIGHELLA
his servant

ZANETTO
Rosaura's fiancé

PANCRAZIO
a friend of Dr Balanzoni

BEATRICE
Tonino's fiancée

FLORINDO
a friend of Tonino

LELIO
Dr Balanzoni's nephew

TONINO
Zanetto's twin brother

ARLECCHINO
Zanetto's servant

PORTER

TIBURZIO
a jeweller

BARGELLO
the Chief Constable

GUARDS

STREET VENDORS

The Venetian Twins was first performed in this translation by the Royal Shakespeare Company at the Swan Theatre, Stratford-upon-Avon in 1993, with the following cast:

ROSAURA, Sarah Woodward

COLUMBINA, Sian Radinger

DOCTOR (Balanzoni), Robin Soans

BRIGHELLA, James Hayes

ZANETTO, David Troughton

PANCRAZIO, Christopher Hunter

BEATRICE, Jenny Quayle

FLORINDO, Jonathan Phillips

LELIO, Guy Henry

TONINO, David Troughton

ARLECCHINO, Ian Hughes

PORTER, Gary Taylor

TIBURZIO, Peter ByGott

BARGELLO, Mike Burnside

GUARDS / STREET VENDORS / SERVANTS, Alexi K Campbell, Simon Coury, Damien Lyne, Caroline Payne, Sara Weymouth, Anita Wright

Director, Michael Bogdanov

Designer, Kendra Ullyart

Lighting Designer, Chris Ellis

Music, Terry Mortimer

Musicians, Ian Reynolds, Edward Watson, Robert Pritchard, Peter Fisher, Kevin Pitt, Peter Morris, David Statham, Nigel Garvey

Literal Translator, Rosanna Bradley

ACT ONE

Scene 1

ROSAURA's room.

ROSAURA and COLUMBINA, both at the dressing table, arranging their hair.

ROSAURA: Columbina, my hair comes first.
COLUMBINA: Signora, I've been standing behind you for two hours – curling, frizzling, crimping. What can I do? You keep sticking your fingers in it and messing it up.
ROSAURA: You minx! How presumptuous can you get? You leave mine in a mess and waste time on your own.
COLUMBINA: Why not? I've got hair too.
ROSAURA: But I'm the mistress; you're the maid.
COLUMBINA: Don't make me say something I'll regret.
ROSAURA: That's enough, you viper! My future husband'll be here any minute – he mustn't see me like this.
COLUMBINA: Mine's coming too – I want to look my best for him.
ROSAURA: You impudent little hussy – how dare you compare yourself to me?
COLUMBINA: You'd better treat me with respect, or else...
ROSAURA: Such insolence! Get up, or I'll have you beaten.
COLUMBINA: Beaten! Me! (*Gets up.*)
ROSAURA: That's no way to speak to your mistress, you beast! I'll tell my father...
COLUMBINA: What a mistress! And what a father! Look, signora – we understand one another very well, he and I.
ROSAURA: What do you mean by that you little bitch?
COLUMBINA: Just you stop calling me names. I'm warning you – if you provoke me, I'll spew the whole thing up.

ROSAURA: Go ahead. As if you could say anything...liar!

COLUMBINA: I could say plenty. I've kept quiet long enough.

Scene 2

Enter DOCTOR.

DOCTOR: What's all this noise?

ROSAURA: She needs a good ticking off. She shows me no respect.

DOCTOR: (*To COLUMBINA.*) What? Is this how you treat my daughter?

COLUMBINA: Take care, signore – I know more than you think. My mother told me everything.

DOCTOR: (*Aside.*) Damn her! (*To COLUMBINA sotto voce.*) For God's sake keep your mouth shut. You can have anything you want. Anything.

COLUMBINA: (*To DOCTOR sotto voce.*) All right, then – I'll suffer in silence. Just so long as you know.

ROSAURA: Well...?

DOCTOR: Come, come – your future husband is coming today – Signor Zanetto Bisognosi – son of the famous Venetian merchant, Pantalone. He was brought up at Bergamo by his uncle Stefanello. He's one of the richest merchants in Lombardy.

COLUMBINA: Don't forget – I'm to be married to his servant. You promised.

DOCTOR: (*Aside to COLUMBINA.*) All right, I'll see to it – but in the meantime...

COLUMBINA: I'll keep my mouth shut.

DOCTOR: Rosaura, have you seen Pancrazio today?

ROSAURA: I see him more or less every day.

DOCTOR: Excellent. He's a fine gentleman. He should have some good advice for you.

ROSAURA: Oh, yes – never stops giving me good advice.

DOCTOR: As long as I live, he can treat my house as if it were his own.

ROSAURA: Oh, good. He's such a great help to us. Always so obliging.
COLUMBINA: Personally, I'd trust him no further than I could throw him.
DOCTOR: What makes you say that?
COLUMBINA: Never you mind.

Scene 3

Enter BRIGHELLA.

BRIGHELLA: Signor Zanetto's just arrived from Bergamo. He's got off his horse and he's at the door, talking to someone he met on the way.
DOCTOR: Thank heaven. (*To ROSAURA.*) I'll go and welcome him – then show him up. (*Goes.*)

Scene 4

ROSAURA, BRIGHELLA and COLUMBINA.

ROSAURA: Brighella – you've seen Signor Zanetto – what do you make of him? Is he handsome? Stylish?
BRIGHELLA: He's not bad looking. Young, too. But a bit of a nincompoop from what I've seen of him. Can't even get off his horse properly. He's the spitting image of his brother Tonino, who lives in Venice. I used to see him there sometimes. But Tonino's a prince. This one's a peasant.
ROSAURA: Oh, dear – he sounds dreadful.
COLUMBINA: (*To BRIGHELLA.*) Is his servant with him? Arlecchino?
BRIGHELLA: Not yet. He's expected with the luggage.
COLUMBINA: Pity. I'm curious to see what he looks like.
BRIGHELLA: And I know why. He's getting you. Isn't he the lucky one.
COLUMBINA: Jealous? (*Beat.*) Tough. (*Goes.*)

Scene 5

ROSAURA and BRIGHELLA.

ROSAURA: Tell me, Brighella – how did you come to know this family in Venice? And why was Signor Zanetto brought up in Bergamo?

BRIGHELLA: I was a servant in the house of a very rich merchant – in Venice – a close friend of the late Pantalone Bisognosi – the father of these twins. Signor Pantalone also had a daughter. He sent her to Bergamo – to his brother Stefanello (very rich, no heirs). That's where he'd sent Zanetto before. I heard the girl was lost. It seems she never reached Bergamo. She somehow disappeared along the way and was never heard of again. That's all I know about them. They're one of the richest, most distinguished merchant families in Venice.

ROSAURA: Sounds all right. Too bad he's not a 'prince' like his brother.

BRIGHELLA: Here he comes with my master. Take a look at him, and see if I'm not telling the truth. (*Goes.*)

Scene 6

Enter DOCTOR and ZANETTO.

ROSAURA: Not bad looking. Perhaps he's not as stupid as Brighella made out.

DOCTOR: Come in. Don't be shy. (*To ROSAURA.*) Signor Zanetto.

ZANETTO: (*To ROSAURA.*) How do?

ROSAURA: Your humble servant.

ZANETTO: (*Aside.*) So this one's the servant. Ee! What a peach! (*To DOCTOR.*) Where's the lass what I'm to wed?

DOCTOR: Here.
 (*Indicates ROSAURA.*)

ZANETTO: She said she were the servant.

DOCTOR: She didn't. She said she was 'your humble servant' – it's a mark of courtesy.

ZANETTO: I see. Not a good start.
DOCTOR: Why?
ZANETTO: There shouldn't be any courtesy in marriage.
ROSAURA: (*Aside.*) He's a bit of a bumpkin – but I quite like the look of him.
DOCTOR: (*To ZANETTO.*) Come now – you mustn't let a little thing like that bother you.
ROSAURA: Signor Zanetto, I mean what I say – I respect you.
ZANETTO: I don't give a damn about that.
ROSAURA: You find me too formal?
ZANETTO: If tha says so.
ROSAURA: I'm not pretty enough for you?
ZANETTO: Don't let's hang about. I come to Verona to get wed. I'm expecting Arlecchino – my servant – with my cash and jewellery.
ROSAURA: It is me you're marrying?
ZANETTO: Ay. But why all this messing about? Take my hand and it's done.
(*They shake hands.*)
ROSAURA: (*Aside.*) What an odd character!
DOCTOR: My dear Zanetto, where marriage is concerned there are certain conventions to he observed. You must say something to your bride-to-be – something polite – affectionate.
ZANETTO: Good idea! (*To ROSAURA.*) I am yours – yours for eternity. I loves tha gradely mug. I've a mind to…
(*To DOCTOR.*) Do me a favour.
DOCTOR: What is it?
ZANETTO: Get out of here. You put me off.
DOCTOR: Very well – I shall. I'm a most obliging man. (*Aside to ROSAURA.*) Be sensible: he may he a blockhead, but he's a rich blockhead. (*To ZANETTO.*) I'll be off then. (*Aside to ROSAURA.*) Don't look a gifthorse in the mouth. (*Goes.*)

Scene 7

ROSAURA and ZANETTO.

ZANETTO: (*To DOCTOR.*) Cheerio. (*To ROSAURA.*) That's it, then – we're wed.
ROSAURA: I hope so.
ZANETTO: Then why are we standing about like dummies?
ROSAURA: What would you like to do?
ZANETTO: Needs tha ask?
ROSAURA: We're going to be married – but the ceremony hasn't been performed.
ZANETTO: Ow much more ceremony dost tha want?
ROSAURA: We'll need a service.
ZANETTO: Look – tha's a mind to wed me.
ROSAURA: Yes.
ZANETTO: And I's a mind to wed thee. That'll do for ceremony.
ROSAURA: You may be right. But that's not how we do things here.
ZANETTO: Oh, in't it? Then I'm off back to Bergamo – to the hills where I were born. Folk celebrate a marriage wi' three words there – 'I DO' – *ceremony*'s up to man and wife.
ROSAURA: I repeat: we do things differently here.
ZANETTO How long will it take?
ROSAURA: At least two days.
ZANETTO: I can't wait that long.
ROSAURA: You're in too much of a hurry.
ZANETTO: Let's get it over now.
ROSAURA: This is an insult!
ZANETTO: I knows a good many lasses as'd want to be insulted like this.
ROSAURA: You oaf! Can't you wait one more day?
ZANETTO: Let's get the job done now, for Christ's sake – then we can go on having ceremonies for as long tha likes.
ROSAURA: Signor Zanetto, if you're making fun of me…

ZANETTO: Make hay whilst the sun shines. Come on – put me out of my misery.
(*He lunges at her.*)
ROSAURA: How dare you?!
ZANETTO: What's up?
ROSAURA: Just calm down, can't you?
ZANETTO: Alright.
(*He tries to kiss her – she slaps him.*)
ROSAURA: Animal!
(*ZANETTO stops in astonishment, touches his cheek, looks ROSAURA in the eye, rehearses the slap, bows to her, and runs out.*)

Scene 8

ROSAURA, then PANCRAZIO.

ROSAURA: God, what a nerve! What insolence! And I thought he was a simpleton. Women should never be left alone with men – it's dangerous. You can never tell by appearances – that's what Pancrazio says. Here he comes – you can tell from his face what a good man he is.
PANCRAZIO: God be with you, dear lady. You seem upset. Is something troubling you?
ROSAURA: Signor Pancrazio, if you knew what's just happened.
PANCRAZIO: Please tell me. You know you can trust me.
ROSAURA: You know my father promised me in marriage to a Venetian?
PANCRAZIO: (*Aside.*) If only he hadn't.
ROSAURA: What you may not know is that he arrived today.
PANCRAZIO: (*Aside.*) I wish he'd broken his neck.
ROSAURA: Well, it turns out he's a fool – and a brute.
PANCRAZIO: Alas, the two often go together.
ROSAURA: My father introduced us straightaway.
PANCRAZIO: That's bad.
ROSAURA: Then left me alone with him.
PANCRAZIO: That's worse.

ROSAURA: And he...
PANCRAZIO: I can guess.
ROSAURA: ...said certain things...
PANCRAZIO: Obscene things?
ROSAURA: Yes.
PANCRAZIO: Did he...er...do anything?
ROSAURA: He did.
PANCRAZIO: Go on. What happened?
ROSAURA: He tried to molest me, so I slapped his face.
PANCRAZIO: Exemplary girl! Worthy of inclusion in the catalogue of our century's heroines! Words cannot express my admiration for your courage. How else should such insolent people be treated? They must be taught a lesson. Oh brave, illustrious, glorious hand! Let me kiss it, in all humility.
(*He takes her hand and kisses it tenderly.*)
ROSAURA: Then you approve?
PANCRAZIO: My dearest Rosaura, it is rare nowadays to find such modesty in a young woman. Cleave to that path. Learn to despise men from whom you can expect only infidelity and ill treatment. By all means, slap them. Slap them with my blessing. Should you ever give your heart, let it be to one who is worthy of it.
ROSAURA: But where will I find him?
PANCRAZIO: My dearest Rosaura, I can say no more at present. But you are dearer to me than you might imagine. Enough. You will know one day.
ROSAURA: I know you're a good man. I'm sure you'll go on helping us. And since you are so good, I feel I should tell you: I quite like Signor Zanetto, If he wasn't so forward, maybe...
PANCRAZIO: No! Please! Do not sully your noble deed with base desires. You should despise so loathsome a man. You are virtuous – you deserve far better. Promise you will never mention his name to me again.
ROSAURA: I'm sorry – really I am. I'll go and tell my father I don't want him.
PANCRAZIO: Well said! I approve. And I shall add my reasons to your own.

ROSAURA: Please don't desert me. (*Aside.*) What a wise, honest man. My father's lucky to have him in the house, and I'm lucky to have his advice. (*Goes.*)

Scene 9

PANCRAZIO: (*Alone.*) I'm not rich, I'm not young; I'm not handsome. If I win Rosaura, it'll be by pretending to be better than I am. Catch as catch can – that's my philosophy.

Scene 10

Street. Enter BEATRICE in travel clothes, with SERVANT and FLORINDO.

BEATRICE: Signor Florindo, I want to return to Venice.
FLORINDO: Why?
BEATRICE: I've been waiting for Tonino for six days now. I was supposed to be going to Milan with him, and he still hasn't arrived. I'm afraid he's either changed his mind or been detained in Venice by some accident. I intend to leave at once and find out for myself.
FLORINDO Isn't that a bit rash? If your relatives find you, you're done for. You did run away from home.
BEATRICE: Venice is a big city. I shall go at night – to avoid being recognised.
FLORINDO: No. Tonino placed you under my protection. I must look after you. It's my duty as a friend. (*Aside.*) Besides, I'm in love with her.
BEATRICE: There's nothing to worry about. I shall find the coach and return to Venice with my servant.
FLORINDO: That would he a serious mistake. You told me yourself, you were pursued on your journey by someone called Lelio. Haven't I seen him pestering you here in Verona? Didn't I have to intervene? If you set off, and he finds out, there'll be no avoiding him.
BEATRICE: An honourable woman does not fear such things.

FLORINDO: But a woman travelling alone, however respectable, is asking for trouble.
BEATRICE: I shall leave no matter what you say.
FLORINDO: Wait two more days.
BEATRICE: Something tells me I have lost my Tonino.
FLORINDO: Heaven forbid! But if it were true, what would be the point of going back to Venice?
BEATRICE: But what good can I do by staying in Verona?
FLORINDO: You might find someone here who appreciates you – who could take Tonino's place...
BEATRICE: Never! I must either be Tonino's (*Beat.*) or death's.
FLORINDO: (*Aside.*) If she stays here, and he doesn't turn up, I might win her round.
BEATRICE: (*Aside.*) I'll get away when he least expects it.
FLORINDO: Here comes Lelio. What an affected, effeminate...
BEATRICE: Let's go.
FLORINDO: No. You mustn't show the slightest fear. Keep calm.
BEATRICE: (*Aside.*) This is all I need.

Scene 11

Enter LELIO.

LELIO: Dazzling Venetian, the coachman tells me you intend to return to Venice. If so, you can rely on my protection. I shall give you coach, horses, footmen, lackey, anything – if you will only grant me the unequalled pleasure of accompanying you.
BEATRICE: (*Aside.*) How ill-bred! How dare he!
FLORINDO: What right have you to make this extraordinary offer to a woman I am escorting?
LELIO: What difference does that make? Why should the deadliest swordsman in Verona be frightened of you? Who are you, anyway? Some sort of guardian? Just what are you after? Her money, I shouldn't wonder.

FLORINDO: I'm astounded at your behaviour. I'm a man of honour. I promised to look after this lady.
LELIO: My friend, I fear you're going to find that promise hard to keep.
FLORINDO: Oh?
LELIO: It takes a better man than you to defend a paragon of beauty.
FLORINDO: I can deal with the likes of you.
LELIO: Enough of this banter. (*To BEATRICE.*) Dear lady, is there nothing I can offer you? Money? Protection? Clothes?
FLORINDO: I'm losing my patience.
LELIO: Really? You seem much too gentlemanly for that. Signora Beatrice, there must be some service I can perform for you. Give me your hand.
BEATRICE: Is there no end to your impertinence?
LELIO: In love one must be bold. What use are formalities? Come with me.
(*He tries to take her hand but she retreats.*)
FLORINDO: Where are your manners?
(*He pushes him.*)
LELIO: Fool! This to me? To me, whom no man in the world has insulted without paying for it with his life's blood? I am the Marquis Lelio, Lord of Montefresco, Count of Fonte Chiara, Magistrate of Selva Ombrosa. I own more land than there are hairs in that badly combed wig of yours – more gold than you've had beatings.
FLORINDO: And you have more crazy notions in your head than there are stars in the sky. (*Aside.*) Count indeed! He's Doctor Balanzoni's nephew.
LELIO: Let the lady come with me – or you will fall before my wrath.
FLORINDO: This lady is in my charge. Claim her and I'll kill you.
LELIO: Unhappy youth! I pity you! Do you really wish to die?
BEATRICE: (*Sotto voce to FLORINDO.*) Don't endanger yourself on my account.

FLORINDO: (*To BEATRICE.*) Don't worry. I can deal with him.
LELIO: Live on. You are young. Leave her to me. The world is full of women – you have only one life.
FLORINDO: Honour means more to me than life. Leave now, or draw your sword. (*Draws.*)
LELIO: I only fight with equals.
FLORINDO: Equal or not – this is how I deal with cowards. (*Gives him a blow with the flat of his sword.*)
LELIO: This to me! Gods, guardians of my noble house – assist me in this adventure. (*Draws.*)
FLORINDO: Let's see what you're made of. (*Draws.*)
BEATRICE: Oh, god! They're going to fight. I can't bear it! I'm going in.
(*BEATRICE goes into the inn with her SERVANT.*)

Scene 12

FLORINDO and LELIO are fighting. TONINO enters.

FLORINDO: Damn! I slipped.
LELIO: Reckless man! You are vanquished. (*He puts his sword to his chest.*) Foolish fellow.
FLORINDO: I slipped, I tell you.
LELIO: This will teach you not to pick quarrels with your betters. My courage defeated you. Die!
TONINO: (*Sword in hand, to LELIO.*) When your opponent is on the ground, you should put up your sword.
LELIO: This isn't your affair.
TONINO: I am a man of honour. Your conduct is unbecoming, sir.
FLORINDO: Tonino! (*Gets up.*) My dear friend…
TONINO: (*To FLORINDO.*) Not so loud – and don't call me Tonino. (*To LELIO.*) Come on, you braggart – turn and face me!
LELIO: (*Aside.*) This is all I need. (*To TONINO.*) I don't believe I've had the honour…
TONINO: I am a Venetian, and one with enough courage to see off ten of your kind.

LELIO: I have no quarrel with you.
TONINO: Be that as it may – I have one with you.
LELIO: Are you insane?
TONINO: When you insult my friend you insult me. In Venice we value friendship above life. I would disgrace the city of my birth if I did not defend him.
LELIO: But how did I insult this worthy friend of yours?
TONINO: You think it's nothing to threaten a man when he's down? To say 'die' when he's flat on the floor? Come on – draw your sword.
FLORINDO: (*To TONINO.*) No – don't endanger yourself on my account.
TONINO: Out of my way. Fighting this pepper-filled paper bag is about as dangerous as sucking an egg.
LELIO: I have suffered your insolence long enough. This is a slur on my honour, and the honour of my forefathers. (*He takes his guard.*)
TONINO: So it is! What would your mother say? (*They fight. TONINO disarms LELIO.*)
Unlike you, I won't say: 'Die!' I shall keep your sword as a memento of my victory. I'll send you the sheath – you can sell it to pay for the bleeding.
LELIO: What bleeding?
TONINO: The one you'll need to get over the fright you've had.
LELIO: Enough! I shall be revenged…
TONINO: Whenever you're ready.
LELIO: We shall see. We shall see. (*Goes.*)

Scene 13

TONINO: Go! And your proudest boast will be that you have now crossed swords with me.
FLORINDO: My dear friend – how can I ever thank you?
TONINO: Don't mention it. Where's Beatrice?
FLORINDO: Beatrice! (*Aside.*) I'd better pretend. (*Aloud.*) Beatrice? Beatrice who?
TONINO: The girl I sent to you.

FLORINDO: Sent to me?
TONINO: Yes, I asked you to look after her till I arrived.
FLORINDO: I'm sorry. I've seen no one.
TONINO: Are you making fun of me?
FLORINDO: No. It's true. I haven't seen the lady you're speaking of. I'd have been only too glad to help.
TONINO: So – she's deceived me. And I thought I'd found a faithful woman. We've been in love for two years. Her father disapproves of me. He thinks I'm a good-for-nothing because I love company and take life as it comes. She had no choice but to elope. She didn't think twice – just packed and left. I stayed in Venice to allay suspicion. But a foreigner, who had designs on her, found out and picked a quarrel with me. One thing led to another. I slapped him. It was the talk of the city. He was set on revenge. I took a gondola and came straight here – without returning home – without money or belongings – expecting to find Beatrice. But the bitch fooled me. Anyway, while I'm here don't call me by my real name. I don't want to be recognised.
FLORINDO: What should I call you?
TONINO: Zanetto.
FLORINDO: Why?
TONINO: I have a brother in Bergamo called Zanetto, who looks just like me. I'll be taken for him. That way I'll be safe.
FLORINDO: This brother of yours – is he still in Bergamo?
TONINO: I'm not sure. We've never been that close. He's richer than me – I enjoy life more than he does. I hear he wants to get married, but I don't know where or to whom. God help whoever gets him. He's a twenty-four carat clot.
FLORINDO: If you're looking for somewhere to stay…
TONINO: No. I don't want to inconvenience you.
FLORINDO: I'd be glad to have you. But, to tell you the truth, my father's difficult – a bit of a recluse.
TONINO: Don't worry. I'll go to the inn.

THE VENETIAN TWINS: ACT ONE

FLORINDO: I'm really sorry about this. Look...
TONINO: Tonino Bisognosi doesn't scrounge off his friends. He gives; he does not take. I am a gentleman. We Venetians give our hearts to strangers. Come to Venice and you'll see. They always prefer it to home. I know you mean well, but a good mother says 'Take', not 'Would you like?'
FLORINDO: Please. Do come.
TONINO: I might, if I'm desperate. I am Tonino Bisognosi – that is enough. My life, my livelihood – all for my country, and then for my friends. Your servant. (*Goes.*)

Scene 14

FLORINDO: (*Alone.*) He has every right to he offended. But what can I do? I love Beatrice, If he stays with me he'll find out what I'm up to. I must arrange things so that he leaves Verona and Beatrice stays. Then I can declare myself. Who knows? She may even welcome my advances. I'll go and find her – keep her out of sight today and make sure her servant leaves town. As for Tonino – I owe him my life, and I'd lay it down for him. But give up Beatrice? Never! First things first, though. I must find her. Where the devil is she? (*Goes.*)

Scene 15

Enter ZANETTO, in pensive mood, still feeling his face where ROSAURA slapped him.

LELIO: So, you're alone. Now we can fight.
ZANETTO: What can I do for you?
LELIO: Don't try to mock me with this loutish speech.
ZANETTO: You what?
LELIO: Never mind. Put your hand on it.
ZANETTO: My hand? Here you are, then.
LELIO: Don't be an idiot! Put it on your sword.
ZANETTO: On my sword?

LELIO: Yes.

ZANETTO: Why?

LELIO: Because I am a courageous man, and will not suffer a defeat to obscure the glory I have won with countless deeds of valour.

ZANETTO: (*Aside.*) 'Ark at him. (*Aloud.*) Where's thee from?

LELIO: I am from Rome. Why?

ZANETTO: Because tha's talking double Dutch.

LELIO: Perhaps you'll understand this glittering steel. (*He puts his hand on his sword.*)

ZANETTO: Help! He's going to kill me!

LELIO: Don't play the fool – I know you're not afraid. But Mars himself would have to yield to me, unless Jupiter disarmed me. *En garde!*

ZANETTO: (*Aside.*) First a slap – now this. 'Ti'n't my day.

LELIO: Bestir yourself, I say. Answer my challenge. (*He gives him a light blow with the flat of his sword.*)

ZANETTO: Ow!

LELIO: Defend yourself, or I shall run you through. (*Makes to strike him.*)

Scene 16

Enter FLORINDO.

FLORINDO: (*Sword in hand.*) I am here to defend my friend! Turn your sword on me

LELIO: (*To FLORINDO.*) This man is an abject coward – a pusillanimous poltroon.

FLORINDO: Nonsense. He's extremely courageous.

ZANETTO: (*Aside.*) A fat lot he knows.

LELIO: Then why will he not face me?

ZANETTO: (*Aside.*) Because I'm browning my boots.

FLORINDO: Because he no longer deigns to.

ZANETTO: (*Aside.*) He's off his chump in all.

FLORINDO: Anyway, it's me you're fighting.

LELIO: Here I am. I can defeat you – and a hundred like you.

(*They fight. LELIO falls.*)
FLORINDO: How are the mighty fallen.
LELIO: Ah, cruel fate – the enemy of valour!
FLORINDO: Your life is in my hands.
ZANETTO: Grand! Skewer him!
FLORINDO: That wouldn't he the action of a gentleman.
ZANETTO: He tried to do me in. Were that 'the action of a gentleman'?
FLORINDO: When I was down, and he threatened to kill me, you rebuked him.
ZANETTO: You're daft! Go on – polish him off.
FLORINDO: No. (*To LELIO.*) Live. And count yourself lucky.
LELIO: You, sir, are a worthy opponent. As for him – he's nothing but a lily-livered lout. (*Goes.*)

Scene 17

ZANETTO: (*Calls after him.*) You're right there! (*To FLORINDO.*) He's proper la-dee-da, he is.
FLORINDO: That wasn't like you. What are you playing at? Were you acting?
ZANETTO: Nay! I've never been so scared in all my life.
FLORINDO: I see. It's just that you don't seem quite yourself. For one thing, your voice…
ZANETTO: My voice? What about my voice?
FLORINDO: Oh – nothing. It just seems – well, different, that's all.
ZANETTO: I don't know what tha's on about.
FLORINDO: You don't? Well – no matter. Thank God I arrived in time to rescue you.
ZANETTO: Let me kiss the hand as saved my life.
FLORINDO: I only did for you what you did for me.
ZANETTO: What did I do?
FLORINDO: You defended me against him the first time.
ZANETTO: Go on! You're pulling my plonker.
FLORINDO: Men like you forget the services they perform – out of modesty. I advise you to leave Verona. You may have been recognised.

ZANETTO: Ay. I thought he knew me.
FLORINDO: If he did, you may be in danger.
ZANETTO: Things is going from bad to worse.
FLORINDO: After all, you did slap someone…
ZANETTO: You mean as someone slapped me.
FLORINDO: Someone slapped you?
ZANETTO: Ay! You didn't reckon as I slapped someone, did you?
FLORINDO: Yes – no – a woman?
ZANETTO: Oh, ay.
FLORINDO: And you haven't seen her since?
ZANETTO: Nay. I've not.
FLORINDO: (*Aside.*) I can't find Beatrice, either.
ZANETTO: I don't care tuppence if I never sees her again.
FLORINDO: Well said. Forget about her. Go home.
ZANETTO: That's just what I'd a mind to do.
FLORINDO: If I can help at all…
ZANETTO: That's all right, thanks.
FLORINDO: Goodbye.
ZANETTO: Tara, and thanks a million.
FLORINDO: (*Aside.*) He seems to have turned into a simpleton. Love can bring about some strange transformations! (*Goes.*)

Scene 18

ZANETTO: What a gent! I'd be in a proper pickle but for him. How did he know about that slap? Oh, well, he seems to like me – and he reckons I should leave. But I like this Rosaura, and I wouldn't mind wedding her. It's a pity Arlecchino hasn't got here with the jewellery and the cash – then I could buy her a present – to make it up, like.
PANCRAZIO: (*Aside.*) There's that wretched Zanetto. Still hanging about the house. I wish he'd leave.
ZANETTO: She slapped me. That's bad. But my mother slapped me, and she liked me. I don't reckon she really meant to hurt me. I'll go and say I'm sorry…
(*He goes towards the DOCTOR's house.*)

PANCRAZIO: Your excellency! Where are you going?
ZANETTO: To see her as I'm to wed.
PANCRAZIO: The one who slapped you?
ZANETTO: Ay.
PANCRAZIO: Then you are determined to be reconciled with her?
ZANETTO: I am that.
PANCRAZIO: Do you like the young lady?
ZANETTO: Oh, ay.
PANCRAZIO: Do you love her?
ZANETTO: Oh, ay – a lot.
PANCRAZIO: And you've set your heart on marrying her?
ZANETTO: Ay. That I have.
PANCRAZIO: I pity you.
ZANETTO: Why?
PANCRAZIO: You are on the edge of a precipice.
ZANETTO: Eh?
PANCRAZIO: You did say you wanted to get married?
ZANETTO: I did an' all.
PANCRAZIO: Unhappy man, you are ruined.
ZANETTO: Why's that?
PANCRAZIO: My only desire is to help my fellow man. I feel it my duty, in brotherly love, to warn you: the step you are about to take is an exceedingly rash one.
ZANETTO: Really?
PANCRAZIO: Do you know what marriage is?
ZANETTO: Well – it's – er – as you might say, man and wife.
PANCRAZIO: Ah, if you were a little wiser, you would not speak of it with such indifference.
ZANETTO: Come on – cut the cackle.
PANCRAZIO: Marriage is a chain that holds a husband like a slave to a galley.
ZANETTO: Marriage?!
PANCRAZIO: Yes, marriage.
ZANETTO: What a load of old rubbish!
PANCRAZIO: Marriage is a burden that makes you sweat by day and keeps you awake at night. It is a burden on

the mind and on the body. And worst of all, it empties the purse.

ZANETTO: You don't say! That's terrible!

PANCRAZIO: And the woman who seems so beautiful at first – so gentle – what do you think she really is?

ZANETTO: Tell me. Tell me.

PANCRAZIO: A siren who will lure you to your destruction. Who will flatter you to deceive and plunge you into penury.

ZANETTO: Really? I'd no idea.

PANCRAZIO: Alas, yes.

ZANETTO: Oh my!

PANCRAZIO: Those flashing eyes of hers are two furnaces that will reduce you to cinders.

ZANETTO: The eyes...two furnaces.

PANCRAZIO: Her mouth is a pot of poison, that slowly insinuates itself into your ears, seeps down into your heart and kills you.

ZANETTO: Her mouth...a pot of poison.

PANCRAZIO: Her cheeks – so soft and rosy – there is witchcraft in them. Be warned – when a woman crosses your path, she is a devil come to drag you down to hell.

ZANETTO: Christ almighty!

PANCRAZIO: Think it over carefully.

ZANETTO: I have, an' all.

PANCRAZIO: No more women?

ZANETTO: Not on your life!

PANCRAZIO: No more marriage?

ZANETTO: (*Shakes head.*) No more marriage.

PANCRAZIO: You will thank me for this.

ZANETTO: I love thee like a father.

PANCRAZIO: You may kiss my hand.

ZANETTO: (*Kisses it.*) God bless thee!

PANCRAZIO: Women...?

ZANETTO: Uhgggh!

PANCRAZIO: Marriage?

ZANETTO: Ahgggh!

PANCRAZIO: Never again?

ZANETTO: Never again.
PANCRAZIO: Certain?
ZANETTO: Abso-bloody-lutely!
PANCRAZIO: Admirable resolve, if I may say so. Well done! (*Goes.*)

Scene 19

ZANETTO, later BEATRICE with SERVANT.

ZANETTO: Phew! Happen I'd have been in a right fix if he hadn't turned up. Marriage – a burden here, a burden there; women – witches, sirens, devils. Ee, what a mess!
BEATRICE: How wonderful! What joy! Here's my Tonino. (*To ZANETTO.*) When did you arrive?
ZANETTO: You get away from me!
BEATRICE: What do you mean? Aren't we going to be married? Didn't you come to Verona to arrange it?
ZANETTO: Ohhhhh, yes – the chain what binds a man like a slave to a galley. I know all about you.
BEATRICE: Chain? What chain? Have you forgotten your promise?
ZANETTO: Promise? I don't know what you're talking about.
BEATRICE: You promised to marry me.
ZANETTO: Oh, yes – marriage. The burden on the body. The burden on the mind.
BEATRICE: Please – look at me. Why are you tormenting me like this? Don't mock me or I shall die.
ZANETTO: (*Aside.*) I can see her eyes blazing. The furnaces flickering.
BEATRICE: Do you suspect me of something? I can explain…
ZANETTO: Shut it! Shut that pot of poison.
BEATRICE: What are you talking about? You make me blush with shame.
ZANETTO: Her cheeks is changing colour. She's a witch!
BEATRICE: (*Approaches him.*) For pity's sake – listen to the plea of a desperate woman.

ZANETTO: (*Backing away.*) Keep away – you…you siren.

BEATRICE: In Heaven's name, what have I done to deserve this?

ZANETTO: Be off with you, you devil. You're going to drag me down to hell. (*Goes.*)

Scene 20

BEATRICE: How can I have heard all that and still be alive? What's happened to my beloved Tonino? Why is he talking like an oaf? Has he gone mad? Perhaps someone's been telling him lies about me. What am I to do? Oh, poor Beatrice! What will become of you? I'll follow him and see if I can discover the truth. Oh, Cupid, God of Love, you brought this misfortune on me; you made me abandon country, parents, friends: guide me through these dangers. If it's my life you want, take it. I'll spill my blood to the last drop before I lose my beloved Tonino. (*Goes.*)

End of Act One.

ACT TWO

Scene 1

Street. On one side, the DOCTOR's house. On the other, an inn with a sign: 'The Two Towers'.

ARLECCHINO, in travelling clothes; a PORTER carrying a trunk and a short cloak.

ARLECCHINO: At last. Verona. Ee, what a town! 'Twere here as Cupid shot his arrow at me, and I never saw 'bloody thing coming. I's to wed a lass as I've never even met.
PORTER: Could we get a move on? I've other jobs to do. I've got to earn a living.
ARLECCHINO: Trouble is, I've not the foggiest notion where that daft master of mine's staying. You've not bumped into Signor Zanetto Bisognosi?
PORTER: Never heard of him.
ARLECCHINO: He's here from Bergamo to get wed. He's to have the mistress – I'm to have the maid. Keeping it in the family, like. He got here before me. Here I am with all his stuff, and I don't know where the Hell he's got to.
PORTER: You'll have trouble finding him. Verona's a big place.
ARLECCHINO: Ta very much. Here he comes now! Let's hide. I wants to play a trick on him. Just you see if he recognises me.
PORTER: You shouldn't play tricks on your master.
ARLECCHINO: Nay, we's pals, him and me.
PORTER: Hurry up, then.
 (*They withdraw.*)

Scene 2

ARLECCHINO, PORTER, TONINO.

TONINO: It's strange – I've had no word of Beatrice: Is it possible that she's betrayed me?
(*ARLECCHINO, wrapped in the cloak, struts up and down in front of TONINO.*)
(*Aside.*) What does this fellow want with me?
(*ARLECCHINO continues to strut up and down in a menacing manner.*)
(*Aside.*) Could he be an assassin, sent to Verona by the man I slapped?
(*ARLECCHINO goes up and down again, stamping his feet.*)
Who are you? What do you want?
ARLECCHINO: (*Laughing to himself.*) What a chump! He doesn't know me.
TONINO: Out with it, I say. What do you want from me?
(*ARLECCHINO makes a provocative gesture.*)
Now we'll see who this swaggerer is. (*Draws sword.*)
ARLECCHINO: Stop! Doesn't tha know me? (*Takes off cloak.*)
TONINO: No, sir – I do not.
ARLECCHINO: (*Aside.*) He's gone barmy! Must be something in the climate.
TONINO: For pity's sake, man, what do you want?
ARLECCHINO: (*Laughing.*) Tha's drunk. And why's tha putting on that posh voice?
TONINO: Don't take liberties with me or I'll slice your legs off.
ARLECCHINO: Steady on! Take a look at these.
(*Gives him a little box full of jewels.*)
TONINO: (*Aside.*) Such beautiful jewels! What does this mean?
ARLECCHINO: Now dost tha know me?
TONINO: No, sir. I do not.
ARLECCHINO: You're a proper caution, you are. All right, we'll try again.
(*Hands him a purse.*)

TONINO: Sorry.
ARLECCHINO: Bloody 'eck. Take a look in trunk. If you won't have owt to do with me then, you can stuff yourself.
TONINO: In your trunk?
ARLECCHINO: Ee, you're either drunk or barmy.
TONINO: On the contrary, it is you who are 'barmy'. These things aren't mine. I'm an honest man. I want nothing to do with them. Take them back to their rightful owner.
ARLECCHINO: But this stuff's yours. You said to bring it. Cash, clothes and jewellery, you said. Where's tha staying?
TONINO: At that inn.
ARLECCHINO: Shall I take trunk in?
TONINO: You can do what you like as far as I'm concerned.
ARLECCHINO: And tha still doesn't know me?
TONINO: NO! I do NOT know you!
ARLECCHINO: Ee, tha's proper daft! Anyroad, I'll take it to thy room. (*He picks up the trunk.*) Have a good sleep. Tha'll know me when tha's sobered up a bit.
(*He goes into the inn.*)

Scene 3

TONINO, later COLUMBINA.

TONINO: Bizarre! A box of jewels, a purse full of money – quite a catch for someone. But I am a man of honour. I don't want anything to do with other people's property. That man is insane. God knows how he came by these things. If he hadn't given them to me, he'd have given them to some scoundrel. I'll look after them and if I find out who they belong to I shall return them to him.
COLUMBINA: Your servant, Signor Zanetto.
TONINO: I beg your pardon?
COLUMBINA: You are Zanetto Bisognosi?

TONINO: Why yes – of course.
COLUMBINA: Only, I didn't recognise your voice. My mistress wants to see you upstairs.
TONINO: (*Aside.*) This sort of thing's always happening to strangers in town. (*Aloud.*) Gladly. I've got time on my hands.
COLUMBINA: What beautiful jewels!
TONINO: (*Aside.*) I see. Her mistress has seen the jewels from her balcony, and sent a go-between.
COLUMBINA: They must be for Signora Rosaura.
TONINO: Is she your mistress?
COLUMBINA: Yes.
TONINO: (*Aside.*) If she thinks she's getting her hands on these, she's got another think coming. This could be fun. (*Aloud.*) I might give them to her, if she's to my taste.
COLUMBINA: No problem there. She's a lovely girl.
TONINO: (*Aside.*) She's a pretty good pimp. (*Aloud.*) How do we go about it?
COLUMBINA: Pardon?
TONINO: The money…
COLUMBINA: She doesn't need money. She's a doctor's daughter.
TONINO: Oh?
COLUMBINA: You know she is.
TONINO: But will he want me in the house?
COLUMBINA: Of course. He told me to ask you in.
TONINO: (*Aside.*) They're all in this together. I don't want to land myself in trouble. (*Aloud.*) Tell your mistress I'll come another time.
COLUMBINA: Oh no, signore. She'd like you to come at once. And if you were a gentleman you'd satisfy her.
TONINO: All right – I'll just take these jewels to my room.
COLUMBINA: Don't be silly. Bring them with you.
TONINO: (*Aside.*) Just as I thought – it is the jewels they're after. I'd better be careful. But I know how to handle myself. (*Closes box.*)

Scene 4

Enter DOCTOR.

COLUMBINA: I've done my best, signore, but he won't come in.
DOCTOR: Signor Zanetto, please – my daughter's waiting for you. You're insulting her with your reluctance.
TONINO: (*Aside.*) My God! It's getting better and better.
DOCTOR: Does she have to come out into the street?
TONINO: Of course not. I'll go in.
DOCTOR: That's more like it.
TONINO: You're sure it's all right?
DOCTOR: Of course. You're always welcome. Any time. Night or day. (*Aside.*) Strange. He seems less of a clod now.
TONINO: Day or night?
DOCTOR: For you, the door is always open.
TONINO: Just for me?
DOCTOR: You – and a few close friends.
TONINO: That's all right, then. And I can come and go as I please?
DOCTOR: Naturally.
TONINO: Take off my clothes and make myself at home?
DOCTOR: Of course.
TONINO: All right. I'll go in.
(*He is about to go in.*)
DOCTOR: (*To TONINO.*) Signor Zanetto, a word in your ear.
TONINO: (*Aside.*) Perhaps he wants a tip.
DOCTOR: Forgive the liberty – what's in that box?
TONINO: (*Aside.*) He's spotted the jewels. (*Aloud.*) This and that. A jewel or two.
DOCTOR: Excellent. She'll be delighted.
TONINO: (*Aside.*) No gentleman, this doctor. (*Aloud.*) If she plays her cards right, she can have them.
DOCTOR: One should be generous with women.
TONINO: I am a man of honour. Neither you nor your daughter will have any complaints about me.

GOLDONI

COLUMBINA: (*To TONINO.*) That's enough. Go in.
TONINO: On my own?
DOCTOR: Be my guest.
TONINO: Excellent! That's how I like it. (*TONINO goes in.*)

Scene 5

COLUMBINA: He's not behaving like a man in love.
DOCTOR: I can't say I blame him. You know what she did to him?
COLUMBINA: No?
DOCTOR: Slapped him.
COLUMBINA: Why?
DOCTOR: I think he was a little free with his hands.
COLUMBINA: She did right. And if you want my opinion, you shouldn't have sent him back in while she was alone.
DOCTOR: She's not. Pancrazio's keeping an eye on her.
COLUMBINA: To hell with him.
DOCTOR: Why do you say that?
COLUMBINA: I can't bear the sight of him. Pious old fart. What's more…
DOCTOR: Yes?
COLUMBINA: He…said certain things…
DOCTOR: Such as?
COLUMBINA: He's pretty free with his hands, too.
DOCTOR: Hold your filthy tongue. The man's a model of respectability – and you're an ignorant, malicious girl. (*Goes.*)

Scene 6

COLUMBINA, later ARLECCHINO.

COLUMBINA: He can say what he likes. That Pancrazio's up to no good.
ARLECCHINO: Where the pink blazes has that madman gone? I've been waiting an hour.
COLUMBINA: What a handsome man!

ARLECCHINO: I'll ask that comely wench if she's seen him. (*To COLUMBINA.*) You've not come across Signor Zanetto Bisognosi?
COLUMBINA: Certainly have.
ARLECCHINO: Here?
COLUMBINA: Yes.
ARLECCHINO: Which way did he go?
COLUMBINA: Into this house.
ARLECCHINO: Who lives there?
COLUMBINA: Signora Rosaura – his bride to be.
ARLECCHINO: D'you know this Signora Rosaura?
COLUMBINA: Very well.
ARLECCHINO: And her maid…?
COLUMBINA: I am her maid.
ARLECCHINO: You!
COLUMBINA: Me.
ARLECCHINO: Dost tha know who I am?
COLUMBINA: No.
ARLECCHINO: Only Arlecchino Battocchio.
COLUMBINA: You? Arlecchino Battocchio?
ARLECCHINO: Ay! That's right!
COLUMBINA: My husband!
ARLECCHINO: My bride!
COLUMBINA: You're handsome!
ARLECCHINO: You're a smasher!
COLUMBINA: What bliss!
ARLECCHINO: (*Aside.*) What a relief!
COLUMBINA: When did you get here?
ARLECCHINO: We can talk indoors.
COLUMBINA: Wait here. I'll speak to my mistress. I don't know if she'll let me.
ARLECCHINO: And I must talk to master.
COLUMBINA: I'll be right back.
ARLECCHINO: All right, chuck. I'm so happy.
COLUMBINA: Honestly?
ARLECCHINO: Cross my heart.
COLUMBINA: (*Aside.*) He's gorgeous! (*Goes in.*)

Scene 7

ARLECCHINO, COLUMBINA from inside the house. Later ZANETTO.

ARLECCHINO: She's just what doctor ordered. What a stroke of luck! She might have had buck teeth and squinted.
COLUMBINA: (*To ARLECCHINO.*) Come in. She's delighted.
ARLECCHINO: I'll be right up.
(*He is about to go in, when ZANETTO spots him from the opposite door.*)
ZANETTO: Where the bloody hell have you been?
ARLECCHINO: (*Turns round.*) Signor Zanetto! What's tha doing here? I thought tha was indoors.
ZANETTO: Where's my stuff?
ARLECCHINO: At the inn, of course.
ZANETTO: Where?
ARLECCHINO: Ee, you don't know your arse from your elbow. There – the 'Two Towers'.
ZANETTO: Everything?
ARLECCHINO: The lot. (*Aside.*) Now his memory's gone.
ZANETTO: Let's go and have a look.
ARLECCHINO: Ay-ay.
ZANETTO: Hast tha got key?
ARLECCHINO: What of?
ZANETTO: My room.
ARLECCHINO: Nay!
ZANETTO: Tha's left 'em like that?
ARLECCHINO: Left what like what?
ZANETTO: The cash and jewellery.
ARLECCHINO: I gave 'em thee.
ZANETTO: I've not seen 'em.
ARLECCHINO: (*Aside.*) He's lost his marbles and no mistake.
ZANETTO: Look, hast tha brought my stuff or not?
ARLECCHINO: Ay! I have.
ZANETTO: All right then, where is it?

ARLECCHINO: Let's go in. You're driving me up bloody wall.
ZANETTO: Keep your hair on! Happen they're in my room.
ARLECCHINO: Happen as reckon as happen as like.
ZANETTO: Ee, tha's a right shower! Come on. (*Goes into inn.*)
ARLECCHINO: How's that for pot calling kettle black? (*They go into the inn.*)

Scene 8

COLUMBINA: (*On the doorstep.*) Arlecchino? Wonderful! He's gone. Oh, well, he may come back, If he doesn't there are plenty more fish in the sea. A girl like me doesn't have to go hunting for a husband.
(*She goes back in.*)

Scene 9

A room in the DOCTOR's house. A table, chairs. TONINO alone, sitting. Later BRIGHELLA.

TONINO: It's been an hour and still no sign of the lady. I hope they don't think I'm one of those fools who pay more the longer they're kept waiting. Tonino Bisognosi isn't fooled that easily. I'm a Venetian – I'm too clever for them. Where is everybody? Service!
BRIGHELLA: What can I do for you, signore?
TONINO: Who are you?
BRIGHELLA: A servant.
TONINO: (*Aside.*) I'll bet. (*Aloud.*) Tell me – is your mistress going to oblige me, or shall I go?
BRIGHELLA: I'll fetch her at once. By the way I was also in service with the Bisognosi family.
TONINO: Do you know me, then?
BRIGHELLA: I knew your brother – a fine gentleman.
TONINO: Where was this?

BRIGHELLA: In Venice.
TONINO: So you knew me...him when he was a boy?
BRIGHELLA: And as a young man. But here she comes.
TONINO: Could you tell them apart?
BRIGHELLA: Oh, yes – I'd know Signor Tonino anywhere. I'm sorry – I must go. We'll talk again another time. (*Goes.*)

Scene 10

TONINO, later ROSAURA.

TONINO: What the hell was he on about? I don't remember seeing him in Venice. There's something fishy going on. I hope he didn't recognise me.
ROSAURA: Sorry to have kept you.
TONINO: That's all right. (*Aside.*) What a face! What a figure!
ROSAURA: (*Aside.*) He's got a strange look in his eyes. Could it be because I slapped him?
TONINO: (*Aside.*) I'm staying in Verona!
ROSAURA: I hope I haven't inconvenienced you.
TONINO: Not at all, signora. I count myself honoured.
ROSAURA: (*Aside.*) That's not his style. And his voice – it's changed. I wonder what he's playing at?
TONINO: (*Aside.*) She seems so modest.
ROSAURA: I'm only here because my father told me to come.
TONINO: I see.
ROSAURA: I wouldn't have been so forward otherwise.
TONINO: (*Aside.*) You see how a father can hasten his daughter's ruin? (*Aloud.*) Then you have no feelings for me?
ROSAURA: On the contrary, I have the highest regard for you.
TONINO: You're very kind. And can I hope for some token of this regard?
ROSAURA: You can hope for anything, provided my father agrees.

THE VENETIAN TWINS: ACT TWO

TONINO: (*Aside.*) Poor creature! I pity her. (*Aloud.*) I don't think you understand me.
ROSAURA: You haven't forgotten the slap.
TONINO: (*Aside.*) How does she know about that? (*Aloud.*) I don't remember such trivia.
ROSAURA: But I do.
TONINO: What does it matter anyway?
ROSAURA: It matters because you're too bold.
TONINO: One must be bold in such a situation.
ROSAURA: Better to be sensible.
TONINO: You're right of course. I won't do it again – as long as you'll love me.
ROSAURA: You can be sure of that.
TONINO: Ah!
ROSAURA: Why do you sigh?
TONINO: I fear you say that to everybody.
ROSAURA: What do you mean: everybody?
TONINO: Nothing. Forgive me.
ROSAURA: What reason have you to say that?
TONINO: Well, I've only just got here. I find it hard to believe that you've fallen in love with me so quickly.
ROSAURA: But the moment I saw you, the ice in my heart melted. I nearly fainted.
TONINO: (*Aside.*) Can I believe her? She's a woman, and not to be trusted.
ROSAURA: And you, Signor Zanetto – do you love me?
TONINO: You're so beautiful – so gentle – one would have to be made of stone not to love you.
ROSAURA: What token can you give me of your love?
TONINO: (*Aside.*) What's she after? Love or money? (*Aloud.*) Anything. I'm at your service. (*Aside.*) I'll put her to the test. (*Aloud.*) May I be so bold as to leave these jewels in your care?
(*He opens the box and shows her the jewels.*)
ROSAURA: They're beautiful! Are they for me?
TONINO: They might be.
ROSAURA: You're too generous. But can't you show your love in some other way?

TONINO I have some money...
ROSAURA: Give it to my father – he keeps the money.
TONINO: (*Aside.*) The daughter haggles – he looks after the cash. (*Aloud.*) Very well.
ROSAURA: But you still haven't given me what I really want.
TONINO: Would you like my shirt?
ROSAURA: I don't want your shirt. I want you.
TONINO: I'm all yours.
ROSAURA: Then we can settle it today.
TONINO: Now, if you want.
ROSAURA: I'm ready.
TONINO: So am I – more than ready!
ROSAURA: Give me your hand.
TONINO: Hands. Feet. Anything you want.
ROSAURA: Let's call two witnesses.
TONINO: What do you want witnesses for?
ROSAURA: So they can be present.
TONINO: Present at what?
ROSAURA: Our wedding.
TONINO: Hang on!
ROSAURA: But you said you were ready...
TONINO: Ready – yes. But a wedding? So soon?
ROSAURA: Go away. You're making fun of me.
TONINO: (*Aside.*) I quite like her. One of these days, I might even consider marrying her. But I don't like this business of inviting men in off the street.
ROSAURA: You're very fickle, Signor Zanetto.
TONINO: Nonsense! I'm a model of constancy. But these things take time.
ROSAURA: One minute you want to dispense with ceremonies – the next, you say you need time to think.
TONINO: When I said I was ready...perhaps I meant...
Enough – I don't want to anger you...
ROSAURA: Not at all. Tell me.
TONINO: If I could perhaps have a taste of your favours.
ROSAURA: Before the wedding? Not a hope!
TONINO: None at all?

ROSAURA: None.
TONINO: What about the jewels?
ROSAURA: If you gave me them with that in mind, you can take them back.
TONINO: To refuse them in such a virtuous way only makes you more worthy of them. It's a pity you have such a wicked father.
ROSAURA: My father? What's he done?
TONINO: You think it's nothing to bring a strange man into his house and place his daughter in such a compromising position?
ROSAURA: He only did it because we're supposed to be getting married.
TONINO: First I've heard of it.
ROSAURA: But you arranged it all. By letter.
TONINO: What letter? Don't you understand – he's enticed me here – he's exploiting your beauty for his own, mercenary motives.
ROSAURA: How dare you!
TONINO: It's true, I'm afraid. But as for you, you're as honest as you are beautiful. Be strong, love me – and perhaps one day you will be my wife.
ROSAURA: This is heart-breaking! If I'd known we weren't to be married, I wouldn't have had the courage to look you in the face. If my father has deceived me, may God forgive him. And if you're making fun of me, it's very cruel. Only remember that I love you – with a love that is pure and honourable. (*Goes.*)

Scene 11

TONINO, later BRIGHELLA.

TONINO: Such a modest daughter and such a wicked father! Marriage. Hmmm… Be careful Tonino. Once it's done, it's done. I made Beatrice a promise and she ran away from home on my account. But where is she? Where did she go? Perhaps she just pretended to be doing it for me, and then ran off with someone else.

She's a woman. Enough said. As for this girl, she's attractive, and her father's not short of money. Yes – I could see myself marrying her.

BRIGHELLA: What can I do for you, signore?

TONINO: Nothing. I'm going.

BRIGHELLA: So soon? Aren't you dining with the doctor?

TONINO: No. And you can tell him from me, he's a scoundrel.

BRIGHELLA: Why? He sent me here to see you were looked after, Signor…Zanetto.

TONINO: I think you know what I'm talking about. But I wouldn't want to deprive you of your tip. Here's half a ducat.

BRIGHELLA: Much obliged. The Bisognosi have always been a generous family. Your…brother in Venice was very open-handed.

TONINO: (*Aside.*) My brother again! (*Aloud.*) When did you last see my brother?

BRIGHELLA: Oh, about two years…

Scene 12

Enter PANCRAZIO.

PANCRAZIO: Brighella, go to your mistress.

BRIGHELLA: Very good, sir.

TONINO: (*To BRIGHELLA.*) No wait – finish what you were saying.

PANCRAZIO: (*To TONINO.*) I'm sorry, your excellency, but he must go. (*To BRIGHELLA.*) Go on – hurry up!

BRIGHELLA: (*To TONINO.*) I'll see you later, signore. (*Goes.*)

TONINO: (*Aside.*) Damn this interruption!

PANCRAZIO: My respects, signor Zanetto.

TONINO: Your servant.

PANCRAZIO: Your excellency, I'm sorry for you. It seems you have not followed my advice.

TONINO: On the contrary, you look like the sort of man whose advice one should always follow.

THE VENETIAN TWINS: ACT TWO

PANCRAZIO: And then... (*Breaks off.*) Forgive me for mentioning it, but your accent – it seems – how can I put this? – rather less plebeian than when we last spoke.

TONINO: You're not the first person who's said that to me today.

PANCRAZIO: However, to continue – I was under the impression that you had taken what I said to heart – and now I find you here.

TONINO: (*Aside.*) Let's see what I can find out. (*Aloud.*) There are some evil people in this house.

PANCRAZIO: Too true.

TONINO: Grasping people.

PANCRAZIO: I do so agree.

TONINO: This doctor, for example. He's a scoundrel.

PANCRAZIO: You are clearly a most perceptive man – you've seen through him already.

TONINO: And the girl?

PANCRAZIO: Not to be trusted.

TONINO: But she's so beautiful.

PANCRAZIO: Appearances can be deceptive.

TONINO: So what are you doing here, with all these wicked people?

PANCRAZIO: I consider it my duty to reform them. I do my best to enlighten them – to make them change their ways. But thus far, my seeds of wisdom have fallen on stony ground.

TONINO: You can't build with rotten wood. All the same, one can't help liking the girl.

PANCRAZIO: She could melt a heart of stone. I pity the man who falls for it.

TONINO: She tried to trap me into marriage.

PANCRAZIO: Not marriage! Please – not that vile word again!

TONINO: Vile? I don't know what you mean.

PANCRAZIO: But, my dear Signor Zanetto, surely you remember: a burden that makes you sweat by day and keeps you awake at night; a burden on the body and on the mind?

TONINO: Rubbish! A burden on the mind? On the contrary, a wife can relieve your anxiety. She looks after the finances and the servants. With that natural feminine cunning, which some people call avarice, she may even – at the end of the year – make profits for the household. You know what the Venetian poet says:
'You'll marry if you've got a brain
And aren't averse to compromise.
Those who oppose what I advise
Are impotent or else insane.'
PANCRAZIO: (*Aside.*) This fellow's not the fool I took him for! (*Aloud.*) But have you forgotten that a woman is a siren who will lure you to destruction? That she will flatter you to deceive and plunge you into penury?
TONINO: Nonsense. What about the frog and the nightingale? A frog is sitting in a ditch with his mouth wide open. A nightingale sees his throat and falls in love with it. She circles him for a while, then dives straight in. He eats her. Whose fault is it – the nightingale's, or the frog's?
PANCRAZIO: (*Aside.*) He's far too good for me! What am I going to to do? (*Aloud.*) I don't know what to say. If you want her, take her. But I beg of you – for your own sake – don't do anything rash.
TONINO: I didn't say I wanted her. I may have defended marriage, but that doesn't mean I want to get married. She's neither fish nor fowl. And you've made me even more suspicious. I think I'll just drop the whole thing.
PANCRAZIO: Excellent! Well said! I heartily approve of your decision.
TONINO: You seem trustworthy. I'll let you into a secret.
PANCRAZIO: I can assure you, it will be safe with me.
TONINO: You see this box of jewels.
PANCRAZIO: Jewels!
TONINO: That's right.
PANCRAZIO: Let me see them. (*Examines them.*) Beautiful! Really beautiful!
TONINO: They were given to me by a lunatic in a shabby coat. I don't know who they belong to, but he must be

frantic by now. I wonder if I could leave them with you – in case he turns up.
PANCRAZIO: You are indeed an honourable man
TONINO: I'm only acting as a gentleman should.
PANCRAZIO: But if – after a diligent search, of course – the owner cannot be found...?
TONINO: Give them as dowries to young brides.
PANCRAZIO: You Venetians have hearts of gold.
TONINO: Lots of people depend on gentlemen like me. Some of us exploit the situation. Others, of whom I am one, act from purely selfless motives. I'd give all I've got for a friend – even the shirt off my back. (*Goes.*)
PANCRAZIO: What an incredible stroke of luck! It seems he's not so clever after all. I shall use his charity to soothe my own ills. If Rosaura wants these jewels, she'll have to pay with the sort of currency that doesn't cost her much, but means a great deal to me. (*Goes.*)

Scene 13

Same street, with inn.

ARLECCHINO comes out of the inn, followed by ZANETTO.

ARLECCHINO: (*At the door, arguing with ZANETTO.*) I'm an honest man, I tell thee. I gave thee the cash – and the jewellery.
ZANETTO: Tha' did no such thing. Tha's a thief.
ARLECCHINO: Tha's lying.
ZANETTO: (*Comes out.*) Tha's a thief. I wants my jewels.
ARLECCHINO: Tha's already had 'em.
ZANETTO: My jewels! My cash! My clothes!
ARLECCHINO: You're off your rocker, you are!

Scene 14

Enter BARGELLO and GUARDS.

BARGELLO: What's all this? Which one's the thief?
ZANETTO: He is. He's my servant. He brought my cash and jewellery from Bergamo and now he's swiped the lot.

ARLECCHINO: That's a load of bloody rubbish. I'm an honest man.
BARGELLO: (*To ARLECCHINO.*) As chief constable of Verona, it is my duty to inform you that anything you say may be taken down and used in evidence.
(*To GUARDS.*) Tie him up and take him to prison.
(*The GUARDS tie ARLECCHINO up.*)
ARLECCHINO: But for the love of Mike, I've not done nowt!
BARGELLO: Prove it and you'll go free.
ARLECCHINO: And in meantime I rot in bloody jail?
BARGELLO: Exactly. And if you know what's good for you, you won't make trouble.
ARLECCHINO: (*To ZANETTO.*) It's all your fault, you daft bastard! If I get out you'll pay for this.
(*Exit with GUARDS.*)
ZANETTO: If you get out I'll have your guts for garters.
BARGELLO: (*To ZANETTO.*) If you're sure he's the thief you must lodge a complaint with the clerk of the court. (*Goes.*)

Scene 15

ZANETTO, later BEATRICE.

ZANETTO: What's he on about? I wants my jewels, that's all. They were left me by my uncle, Signor Barba. Used to count them all the time, he did. He'd taken them with him all the way from Venice to Bergamo.
BEATRICE: Oh, my beloved Tonino! Have pity on me!
ZANETTO: (*Aside.*) Them furnaces! That pot of poison!
BEATRICE: For pity's sake, don't go! Listen – if only for a moment. All I ask is this – (*Kneels.*) – here I am at your feet – let my tears move you to pity.
ZANETTO: (*Holds his hands in front of her eyes; aside.*) They don't feel all that hot. Nay – them's not furnaces.
BEATRICE: Please – I beg of you – listen.
ZANETTO: (*Aside.*) She's a nice little mouth – I wouldn't mind being poisoned.

BEATRICE: For you I have risked my life, my honour.
ZANETTO: For me?
BEATRICE: For you, whose love I prize above my life. For you the constant object of my thoughts.
ZANETTO: Tha loves me?
BEATRICE: Yes. I love you. I adore you. You are my life; my soul.
ZANETTO: (*Aside.*) She's quite comely, as devils go.
BEATRICE: Please put me out of my misery. Give me your hand.
ZANETTO: (*Aside.*) No rigmarole, either.
BEATRICE: For God's sake, don't make me suffer like this.
ZANETTO: What dost tha want me to do?
BEATRICE: Give me your hand.
ZANETTO: Take both if tha wants 'em. (*Gives her both hands.*) What a hand! Soft as silk!

Scene 16

FLORINDO: (*Aside.*) Damn! He's found her. I must do something.
BEATRICE: If we could only find a witness.
ZANETTO: What about that chap over there?
BEATRICE: Signor Florindo – we're reconciled at last. We're going to be married. Will you be our witness?
ZANETTO: Ay, signore, our witness.
FLORINDO: I'm reluctant to do this – but since it's for a friend. (*To ZANETTO.*) A word, if you please.
ZANETTO: Gladly. (*To BEATRICE.*) Don't run away – I'll be right back.
FLORINDO: (*Pointing to DOCTOR's house.*) Tell me – you've been in there, haven't you?
ZANETTO: Ay, signore.
FLORINDO: Why, may I ask?
ZANETTO: To arrange my marriage – to doctor's daughter.
FLORINDO: And now you want to marry Signora Beatrice?
ZANETTO: That's right.

FLORINDO: But you gave Signora Rosaura your word.
ZANETTO: I'll wed 'em both. (*To BEATRICE.*) I'll be right with you.
FLORINDO: Are you making fun of me?
ZANETTO: Nay. I can marry six women if I've a mind to.
FLORINDO: For God's sake man, this isn't Turkey.
ZANETTO: All right, then – I'll marry this one. (*To BEATRICE.*) I'm coming.
FLORINDO: I'm afraid that's impossible.
ZANETTO: Why?
FLORINDO: Because you promised to marry the doctor's daughter. If you break your word, you'll go to jail for breach of promise.
ZANETTO: (*To BEATRICE.*) Sorry – it's off.
BEATRICE: What did you say?
ZANETTO: I'm not wedding thee after all.
BEATRICE: I don't understand.
ZANETTO: That's as may be.
BEATRICE: Is this how you mock me?
ZANETTO: Happen I's never been to jail and I doesn't want to now.
BEATRICE: To jail!
ZANETTO: This is what it comes to: I can't marry two lasses, and I've already promised to marry doctor's daughter. (*Goes.*)

Scene 17

BEATRICE: What misery! Tonino has gone mad. I hardly recognise him.
FLORINDO: Signora Beatrice, I can explain: he's in love with Rosaura Balanzoni – a doctor's daughter. It's affected his mind.
BEATRICE: Oh Heavens! Can this be true?
FLORINDO: Only too true, I'm afraid. You must be blind not to see it.
BEATRICE: I said myself I hardly knew him.
FLORINDO: What will you do now?
BEATRICE: If Tonino abandons me, I shall die.

Scene 18

Enter LELIO.

FLORINDO: If he does, I am ready to serve you.
LELIO: If Tonino deserts you, here is a champion to avenge you.
FLORINDO: I'll always he faithful to you.
LELIO: With me, you shall know happiness beyond your wildest dreams.
FLORINDO: I'm a lord.
LELIO: The blood that flows in my veins is as illustrious as any in Italy.
FLORINDO: I'm rich.
LELIO: Among my possessions are gold mines.
FLORINDO: I'm handsome.
LELIO: In me you may behold one of nature's finest creations.
FLORINDO: (*To BEATRICE.*) Pay no attention to this caricature of a man.
LELIO: Do not allow yourself to be seduced by this penniless popinjay.
FLORINDO: I'm yours if you want me.
LELIO: You can be mine, if you wish.

Scene 19

TONINO: (*Aside, watching from the side of the stage.*) What's this? Beatrice? Here? With two...
FLORINDO: Speak, my darling.
TONINO: (*As above.*) 'My darling'!
LELIO: Beautified Venetian – untie your lips!
TONINO: (*As above.*) 'Beautified Venetian'! What's going on?
FLORINDO: Tonino has betrayed you.
LELIO: He is an ungrateful wretch.
TONINO: (*Comes forward; to BEATRICE.*) Tonino has not betrayed you. Nor is he an ungrateful wretch. (*To FLORINDO.*) This from you! Hypocrite! Man of straw!

FLORINDO: But Signora Rosaura...
TONINO: Signora Rosaura? That's enough from you. You've revealed my name; you've slandered me – from this day forward don't cross my path, or I'll make a sieve of your belly.
LELIO: May I say...?
TONINO: No you may not, you caricature of a man! Take care – last time I disarmed you – this time I'll cut your heart out. She belongs to me. (*Takes BEATRICE by the hand.*) That is enough.
BEATRICE: I belong to you... But you just said...
TONINO: We'll talk later. Come with me. (*To LELIO and FLORINDO as he goes.*) You puffed-up braggarts! You pepper-filled paper bags!
(*Goes, with BEATRICE.*)

Scene 20

FLORINDO: If I don't avenge myself, my name's not Florindo.
LELIO: I shall not rest until I've destroyed that insolent coxcomb.
FLORINDO: We've both been made fools of.
LELIO: We must join together in vengeance.
FLORINDO: Let's go and plot it.
LELIO: My intelligence is second to none. I'm certain to devise some brilliant scheme.
FLORINDO: We'll go for him together – with our swords.
LELIO: Better still – let's shoot him in the back.
FLORINDO: That would be cowardly.
LELIO: My dear fellow, winning's what matters – not the way it's done. (*Goes.*)
FLORINDO: Very heroic, I must say. I'll handle this on my own. Beatrice will be mine – or Tonino shall feel my sword. (*Goes.*)

End of Act Two.

ACT THREE

Scene 1

Street.

PANCRAZIO and TIBURZIO.

PANCRAZIO: Signor Tiburzio – just the man I've been looking for.
TIBURZIO: Signor Pancrazio, what can I do for you?
PANCRAZIO: I want to sell some jewels. They belonged to a delightful old widow. She left them in my care, with instructions that I was to give them to young girls as dowries. Would you be so kind as to provide me with a valuation?
TIBURZIO: Certainly.
PANCRAZIO: Here they are. (*Takes out the box; opens it.*) Examine them carefully.

Scene 2

BARGELLO and GUARDS enter and watch from a distance.

TIBURZIO: Signor Pancrazio, these jewels are extremely valuable. I couldn't put a price on them here. You'd better come to my shop.
PANCRAZIO: Why, certainly. They're rather dirty. Is there no way of cleaning them?
TIBURZIO: As a matter of fact, I do have something. But I have to be discreet about it – it's extremely poisonous.
PANCRAZIO: I would not dream of abusing your confidence. You know me.
TIBURZIO: I know you're a good man, and an honest one. I happen to have some with me. Take it – they'll be sparkling in no time, you'll see. (*Hands him the powder.*) If you do decide to sell them, I'll be pleased to act on your behalf. I'll get you an excellent price.

PANCRAZIO: I will not hesitate to avail myself of your offer. Meanwhile, I'm extremely grateful to you. I'll see you tomorrow.

TIBURZIO: Always at your service. (*Goes.*)

Scene 3

BARGELLO: (*To GUARDS.*) If you ask me, those are the missing jewels.

PANCRAZIO: (*Aside.*) Perhaps this present will be my passport to Rosaura's bed.

BARGELLO: Stop, signore, if you please.

PANCRAZIO: What is it? What do you want?

BARGELLO: To do my duty as an officer and inspect those jewels.

PANCRAZIO: Why?

BARGELLO: I've reason to believe they're stolen property.

PANCRAZIO: How dare you? I am a gentleman.

BARGELLO: So what? Just tell me how they come to be in your possession.

PANCRAZIO: Signor Zanetto Bisognosi gave them to me.

BARGELLO: A likely story. Signor Bisognosi reports them stolen. I hereby issue you with an official warning: you are under suspicion of theft.

PANCRAZIO: How dare you talk to me like that?

BARGELLO: Do you want a bit of advice? In your position I'd try to make myself agreeable.

PANCRAZIO: I'm innocent.

BARGELLO: That's what you say. Let's see if you can prove it. I'm taking these jewels to the law courts.

PANCRAZIO: But, my dear chief constable, I have a reputation to maintain.

Scene 4

PANCRAZIO: Here is Signor Zanetto. (*To ZANETTO.*) Your excellency, please be so good as to tell the constable here how I came by these jewels.

ZANETTO: Jewels? My jewels?

BARGELLO: Signor Zanetto, do you recognise these jewels?

ZANETTO: Ay. My uncle left them to me.

PANCRAZIO: (*To BARGELLO.*) Hear that? He inherited them – from his uncle.

BARGELLO: (*To ZANETTO.*) And you gave them to this man?

PANCRAZIO: That's right – he did. (*To ZANETTO.*) You did, didn't you?

ZANETTO: I never gave you nowt.

PANCRAZIO: What are you saying?

ZANETTO: Them jewels is mine.

PANCRAZIO: Oh, God! Do you want me to lose my reputation?

ZANETTO: (*To PANCRAZIO.*) You can lose what you bloody well like, for all I care. (*To BARGELLO.*) Give me my jewels back.

PANCRAZIO: For God's sake, you gave them to me in the doctor's house – in Signora Rosaura's room – and you know perfectly well why.

ZANETTO: That's a lie. And 'ti'n't first you've told. You said women's eyes was furnaces. 'Ti'n't true.

PANCRAZIO: Signor Bargello – you're an intelligent man – surely you can see this fellow's mad. Please – be reasonable – give me the jewels.

BARGELLO: Mad or not, we're taking them to the judge. It'll be up to you to prove how you came by them. (*To GUARDS.*) Take Arlecchino to the law courts. (*GUARDS go.*)

PANCRAZIO: I'll find witnesses – the doctor, his daughter, Columbina, the entire household. Wait for me. My reputation! My reputation! (*Goes.*)

Scene 5

ZANETTO: Stop messing about and hand over my jewels.

BARGELLO: We're taking them to the judge. If his worship says you can have them, you can.

ZANETTO: What business is it of 'his worship'? Give me my jewels.
BARGELLO: Can't be done, I'm afraid – not unless I get permission. I'd lose my job.
ZANETTO: Suppose he says no.
BARGELLO: Why, in that case I can't possibly give them to you.
ZANETTO: So what will you do with 'em?
BARGELLO: Whatever his worship tells me to, of course.
ZANETTO: You mean I stands to lose 'em?
BARGELLO: That's how the system works.
ZANETTO: We should have left 'em with that old man. At least he took the trouble to steal 'em.
BARGELLO: Surely you're not suggesting that his worship intends to appropriate them?
ZANETTO: What's the difference between hanging on to 'em and stealing 'em?
BARGELLO: Take my advice – get yourself a lawyer.
ZANETTO: What would I want with a lawyer?
BARGELLO: He can help you prove that the jewels are yours.
ZANETTO: I know they're mine. I don't need proof.
BARGELLO: But what good is that if no one will believe you?
ZANETTO: You mean they'll take lawyer's word against mine?
BARGELLO: No, it's not like that. But a lawyer will know how to present your case.
ZANETTO: Must I pay him?
BARGELLO: Of course. You pay him his fee.
ZANETTO: And judge?
BARGELLO: He, too, requires his fee.
ZANETTO: And you? Do you get paid, an' all?
BARGELLO: Naturally. And so do all my men.
ZANETTO: So let's just see if I've got this right: twixt judge, lawyer, you and guards... I can kiss goodbye to what's mine by rights.
BARGELLO: You don't suppose we work for nothing.

THE VENETIAN TWINS: ACT THREE

ZANETTO: Ta very much! I'm off back to my hills. There are no judges there – no lawyers, no guards. There, what's yours is yours, and you don't go bankrupt trying to get justice. Divide the jewels amongst yourselves. You crooks! Take the shirt off me back – I'll not complain. Does it matter to a sheep whether it's eaten by wolves or killed by butcher? Nay. And it don't matter to me whether I'm robbed by you fellows or a band of bloody thieves! (*Goes.*)

BARGELLO: He's mad. Never mind: we constables aren't easily rattled. (*Goes.*)

Scene 6

TONINO alone.

TONINO: So much for friendship. When Florindo was in Venice I treated him like a brother. I left the woman I love in his care, and now he's betrayed me. It's beyond me how a man can betray his friend. But then, these days, everyone worships the idol of self-interest. Instead of friends, one finds oneself surrounded by flatterers whose sole motive is financial gain. And if you lose your money? They abandon you. As Ovid puts it:
'Friends flock to you when things are going well –
Desert you when you've nothing left to sell.'

Scene 7

Enter LELIO.

LELIO: (*Aside.*) There's my rival. Perhaps my blandishments can allay his resentment.
TONINO: (*Aside.*) At least I'll make this one pay.
LELIO: I salute the sublime courage of the most celebrated swordsman in all Italy.
TONINO: I loudly proclaim your resounding greatness.
LELIO: Pardon me if, with my tedious utterances, I dare to offend the tympana of your ears.

TONINO: Regurgitate the trumpet of your eloquence, and I will let you touch not only their tympana but their drums.

LELIO: Permit me to inform you that I am delirious.

TONINO: Yes. I did spot that.

LELIO: Cupid, with his poisonous arrow, has wounded my hitherto impenetrable heart.

TONINO: And your brain as well, I'd say.

LELIO: Signor Zanetto – you are a Bisognosi – assist me.

TONINO: How?

LELIO: I am on fire with love.

TONINO: What do you want me to do about it?

LELIO: You alone can heal my wounds.

TONINO: Where are you from?

LELIO: I come from a city of benighted souls, born beneath a baleful, an abominable star and raised among cut-throats and desperadoes.

TONINO: Well you'll die in a madhouse.

LELIO: I will cut the thread of my labyrinthine discourse with the scissors of brevity. I love Beatrice. I pine for her. Your generosity is incomparable, infinite – give her to me.

TONINO: I will cut the knot of my reply with the blade of frankness. Beatrice belongs to me, and I would give up all the treasures of the Indies before I surrendered her. Why, she is the rarest object of wonder to have shot forth in our latter times. (*Aside.*) Damn! He's got me doing it now!

LELIO: You are sentencing me to death.

TONINO: One lunatic less.

LELIO: Cruel man!

TONINO: Verbose buffoon.

LELIO: If my love should turn to fury you will shake before my rage.

TONINO: Oh, really?

LELIO: I warn you – if our paths cross again...

TONINO: I wouldn't bat an eyelid, you lunatic.

LELIO: Then I shall depart...

TONINO: Do.
LELIO: I mean it.
TONINO: Me, too.
LELIO: I go, and will devise some revenge before the sun has hidden its rays beneath the horizon.
(*Exit LELIO.*)

Scene 8

TONINO, PANCRAZIO and BRIGHELLA.

PANCRAZIO: (*To BRIGHELLA.*) Let's go and see the judge. You can testify to my innocence.
BRIGHELLA: Here's Signor Zanetto.
PANCRAZIO: (*To TONINO.*) How could you deny that you gave me those jewels?
TONINO: Deny it! Of course I gave them to you.
PANCRAZIO: (*To BRIGHELLA.*) Hear that? (*To TONINO.*) You must tell the judge.
TONINO: What's he got to do with it?
PANCRAZIO: You have put my reputation at risk.
TONINO: (*Aside.*) They must have found the owner. (*To PANCRAZIO.*) They didn't think you'd stolen them?
PANCRAZIO: They did. And it is you who are to blame.
TONINO: My dear sir, I did it with the best intentions.
PANCRAZIO: Be that as it may, you have ruined me.

Scene 9

Enter ARLECCHINO.

ARLECCHINO: Out at last.
TONINO: Here's the fellow who gave me the jewels.
ARLECCHINO: Gave you the jewels?
TONINO: That's right.
ARLECCHINO: And the money?
TONINO: Yes.
ARLECCHINO: But you said I hadn't. You'd contradict 'Devil himself, you're that contrary.

TONINO: What utter nonsense. You forced those jewels on me – and the money. I don't need charity and I'd certainly never take what didn't belong to me. I don't have the jewels any more. I understand they're with the judge. Recover them and do what you like with them. As for the money – it's not mine – take it. A man of my breeding values his reputation above all the money in the world.
(*He throws the purse at his feet, and goes.*)

Scene 10

ARLECCHINO: (*Sings.*) He's bar-my!
BRIGHELLA: Must be. I'll follow him – out of curiosity. (*Goes.*)
PANCRAZIO: I shall keep this until he regains his sanity. Come with me to the law courts. I must recover the jewels.
ARLECCHINO: Take me back to Bergamo!
PANCRAZIO: Why do you say that?
ARLECCHINO: There's summat about climate here as drives folk mad.
PANCRAZIO: The air is the same wherever one goes. Madness is everywhere. One can be mad with jealousy, mad with greed, mad with pride… I am mad with love, and I fear mine is the greatest madness of all. (*Goes.*)

Scene 11

ZANETTO: Love's a queer thing! As soon as I saw that Rosaura I started sizzling like a chicken on a spit. I must see her. Happen we can settle this job once and for all.
(*He knocks at the door of the DOCTOR's house.*)
ROSAURA: (*Coming to the window.*) Signor Zanetto!
ZANETTO: Shall I come up?
ROSAURA: No. My father doesn't want you to.
ZANETTO: How come?
ROSAURA: He doesn't like being called a pimp.

THE VENETIAN TWINS: ACT THREE

ZANETTO: How d'you mean? Is I wedding thee or not?
ROSAURA: Yes. I've seen the letter.
ZANETTO: Ay – my letter.
ROSAURA: Now you say you wrote it – before you said you hadn't.
ZANETTO: That's rubbish. I said we could wed at once.
ROSAURA: I don't understand you: one minute you seem stupid – the next a little too clever.
ZANETTO: I'm getting a stiff neck down here.
ROSAURA: Well, you're not coming up.
ZANETTO: All right, then – you come down.
ROSAURA: I can't be seen in the street with you.
ZANETTO: Dost tha want me to die of love?
ROSAURA: You poor thing!
ZANETTO: That's right. I'm a fish out of water away from thee. Help me or I'll drop dead on thy doorstep.
ROSAURA: Very funny!
ZANETTO: Come down – or let me come up! I promise I'll be good.
ROSAURA: Can't you behave yourself from a distance?
ZANETTO: I can't do nowt from this distance.
ROSAURA: What would you do if you were nearer?
ZANETTO: I'd... I'd... I'm too shy to say it. If tha doesn't mind, I'll sing it.
ROSAURA: And I'll listen – with pleasure.
ZANETTO: Sweet girl, if I were close to you –
Closer by far, my love, than this –
I know exactly what I'd do...
I'd steal a kiss.

Oh yes, if I were close to you,
I would – I would – well, need I say?
The Devil doesn't want me to –
To my dismay.

How forthright must a lover be?
On that soft pillow of a breast
I would (I know you follow me)
At last find rest.

I'm dying – let me come upstairs:
An hour is ample to impart
The turmoil of tempestuous cares
Here in my heart.

I would... I would... But now I blush
To tell you what I want to do –
What need for all this tedious gush
Between us two?

ROSAURA: That was lovely!
ZANETTO: Was tha listening? I'm here if tha wants me.
ROSAURA: I'd like you to explain one thing. You seem to be two different people – sometimes stupid, sometimes intelligent – sometimes forward, sometimes shy. What does it all mean?
ZANETTO: I don't know myself. Something gets into me. It's your eyes... I could... I could...
ROSAURA: You're talking nonsense.
ZANETTO: I can explain it that much better down here.
ROSAURA: Do you know what I think? I think you're pretending. You don't love me at all.

Scene 12

Enter BEATRICE and SERVANT.

BEATRICE: (*Aside.*) Tonino? Talking to a woman?
ZANETTO: I love thee so much – without thee I'm like a stallion wi'out a mare; a ram wi'out a sheep; a...a...a room wi'out a view. I love thee. I want to drown myself in the sea of thy beauty. I want to roll about in thy love like a donkey in th'sand.
ROSAURA: (*Aside.*) He's getting carried away.
BEATRICE: Why you wicked, ungrateful, unfaithful wretch! Are these the promises of love that set my heart on fire? Just now you were ready to marry me. Now you betray me. This is the third time you have deceived me... Look at me, wicked man! Look me in the face if you dare. But no – you're blushing like a woman. You're tongue-tied

with remorse. My anger terrifies you. Ungrateful, treacherous, perjured man! Why did you deceive me in my father's house? Why did you make me abandon my country – promise to marry you – if you'd already agreed to marry someone else? Oh, I was told about your wickedness, but I refused to believe it. Now I see the truth. Now I see how I have been spurned – dishonoured. Go! I never want to see you again. I release you from your vows – though I doubt if God will. Brute! Monster! Love my rival. Feast your eyes on her. Oh, yes – she's more beautiful than me. But never hope to find a woman as faithful, nor a love as true, as Beatrice's. Wait there… To release you once and for all, I shall return the letter you deceived me with.
(*She goes, followed by her servant. ZANETTO has been listening attentively, without saying a word.*)
ZANETTO: (*To ROSAURA.*) What were we saying?
ROSAURA: What is there to say? Perjurer! You gave your promise to another woman. Now you want to deceive me. Well you won't get away with it – wicked, perfidious man! Love the woman you are duty bound to love. Marry her, since you've given her your word. Wait! I want to show you how little I care for you – how much I loathe and despise you. I'm going to fetch the letter in which you engaged yourself to me. Then you will see – ungrateful lover – how Rosaura answers treachery. (*Goes back in.*)

Scene 13

ZANETTO alone.

ZANETTO: One says 'brute', 'tother says 'perjurer'. What next? Ee, I'm that desperate! They all shout at me – none of them wants me. I'll never be wed. Where can I find a rope to hang myself? Where can I find a knife to cut my throat? Damn my bad luck – and my good looks. (*Goes.*)

GOLDONI

Scene 14

ROSAURA, later TONINO.

ROSAURA: (*At the window, with letter.*) What! Has the wretch gone? I flattered myself he would wait, but shame and confusion made him leave. I shall have him hunted down. Then he will have a taste of my revenge.
(*Enter TONINO.*)
But here he is. You're shameless! You have the impudence to show yourself again! Go away! I don't care about you any more. Here's your letter. Look – torn to pieces. This is what I'd like to do to your treacherous heart. (*She tears the letter up, throws the pieces down and goes back in.*)

Scene 15

Enter BEATRICE and SERVANT.

Without speaking, TONINO looks up at the window, then picks up the pieces of the letter.

BEATRICE: (*With a letter in her hand.*) I've finally found that wretched letter. Here it is, traitor! Look – this is what I think of it. (*She tears it up and throws it on the ground, then goes, followed by SERVANT.*)

Scene 16

TONINO: What's going on? They tear their letters up and throw them at me. I've never written to Rosaura, and I've never been unfaithful to Beatrice. Either they're both mad, or there's been some misunderstanding. (*Joining the pieces, he reads BEATRICE's letter.*) 'I promise to Signora Beatrice…et cetera…that I, Tonino Bisognosi, et cetera…' This is all right. (*Picks up ROSAURA's letter, joins the pieces and reads.*) 'This is to confirm…that Signora Rosaura Balanzoni and Signor Zanetto

Bisognosi…' Where's the signature? 'ettoZan nosiBisog' (*Rearranges the relevant fragments.*) 'Zanetto Bisognosi!' I'll get to the bottom of this if it's the last thing I do. That servant will tell me what I need to know. But I must be discreet. I mustn't give away my true identity. Hello there! (*Knocks at door of DOCTOR's house.*)

Scene 17

BRIGHELLA opens the door.

BRIGHELLA: It's you, signore! I'm afraid you can't come in.
TONINO: Why not?
BRIGHELLA: My mistress is very upset and the master's in a terrible rage. You'd better go. If they see you there could be an incident.
TONINO: What have I done?
BRIGHELLA: I've no idea. I hear them moaning and groaning but I'm damned if I know what it's all about.
TONINO: You said you knew my brother in Venice.
BRIGHELLA: That's right.
TONINO: Does he look like me?
BRIGHELLA: You're like two halves of an apple.
TONINO: And you haven't seen him for two years?
BRIGHELLA: Give or take a month or two.
TONINO: My brother…
BRIGHELLA: Yes. Signor…Tonino.
TONINO: And who am I?
BRIGHELLA: Signor…Zanetto.
TONINO: Who's come from…?
BRIGHELLA: Bergamo – to marry signora Rosaura.
TONINO: Excellent! (*Aside.*) All is revealed.
BRIGHELLA: By the way…pardon my curiosity…did you hear anything of your sister?
TONINO: Never. Then you know she was lost?
BRIGHELLA: Of course. Your father – God rest his soul – often talked about it.

TONINO: I've no more news of her. My father sent her to Bergamo – and she was lost on the way. No one knows how.

BRIGHELLA: What can you do? One dowry less. If there's nothing else, I'd better go back in. If they catch me talking to you, there'll be trouble.
(*He goes back into the house.*)

Scene 18

TONINO, later COLUMBINA.

TONINO: Much obliged, friend. The world is full of coincidences. Who would have thought it? My brother's in Verona and our paths haven't crossed! Now I understand the business with the jewels and the money. They must be my brother's – and that Arlecchino is his servant. If I'd known I wouldn't have given them away. I'd give anything to see him.
(*COLUMBINA emerges from the house.*)

COLUMBINA: I don't know – the way that cow Rosaura goes on about Signor Zanetto – it gets my goat.

TONINO: What's wrong, girl?

COLUMBINA: Signore, I'm upset because of you.

TONINO: Because of me? Why?

COLUMBINA: It's that uppity bitch, Rosaura. Who does she think she is, to go around badmouthing people?

TONINO: She must be saying terrible things about me.

COLLUMBINA: Such language! All because I took your part. But I know who she really is.

TONINO: She's the doctor's daughter, isn't she?

COLUMBINA: A plague on her. She's a nobody. Found in the street by a pilgrim.

TONINO: Then why does he claim she's his daughter?

COLUMBINA: He's a crook. He's after the inheritance.

TONINO: (*Aside.*) I knew he was up to something. (*To COLUMBINA.*) And you don't know who her father is?

COLUMBINA: We don't know, and we never will.

TONINO: How long has he been passing her off as his?
COLUMBINA: Since she was in nappies.
TONINO: How old is she?
COLUMBINA: Twenty-one – she says.
TONINO: She can't be much more. Where did this pilgrim come from?
COLUMBINA: Venice.
TONINO: Where did he find her?
COLUMBINA: In the lowlands of Caldiera, apparently. Somewhere between Vicenza and Verona.
TONINO: Was she in baby clothes?
COLUMBINA: Of course.
TONINO: Did you see them?
COLUMBINA: No. I think the doctor kept them.
TONINO: And how did this pilgrim come to have her? Was she his child? What was her name?
COLUMBINA: She wasn't his. He found her on the road. Some bandits had robbed a group of travellers. She was the only one left alive. She didn't know her name – the doctor called her Rosaura.
TONINO: (*Aside.*) This is wonderful! She must be my sister, Flaminia. She was lost on the road between Verona and Venice, when my mother was killed. She was taking her to Bergamo.
COLUMBINA: (*Aside.*) Why's he talking to himself?
TONINO: You wouldn't know if there was a medallion among her baby clothes – with two portraits on it?
COLUMBINA: I did hear something about it. Why are you asking all these questions?
TONINO: You'll find out. (*Aside.*) She's definitely my sister. What a happy coincidence! Two brothers and a sister all here – together! It's like something in a comedy.
COLUMBINA: (*Aside.*) Knowing my luck she'll turn out to be a lady. (*Aloud.*) If she's someone important, please don't tell her I called her all those names.
TONINO: Don't worry. I know maids – always maligning their mistresses. (*Goes.*)

Scene 19

COLUMBINA, later PANCRAZIO and DOCTOR.

COLUMBINA: I'm afraid I've said too much. He asked so many questions. I've a feeling something's about to happen.
DOCTOR: Columbina, what are you doing in the street?
COLUMBINA: I came to see if the vegetable man was here.
DOCTOR: Back inside.
COLUMBINA: Have you seen Signor Zanetto?
DOCTOR: Back in the house, you little gossip.

Scene 20

DOCTOR and PANCRAZIO.

DOCTOR: Signor Pancrazio, you're my dearest friend. I'll confide in you: I've decided that my daughter's marriage should be celebrated immediately, in spite of all that's happened.
PANCRAZIO: But my dear doctor, why? She's torn his letter up in his face. She doesn't want him.
DOCTOR: She did that out of jealousy. Things have gone too far. If we stop the marriage now, I'll lose face. It's the talk of Verona. And then, Signor Zanetto is very rich. With only a small dowry I can secure a fortune for my daughter.
PANCRAZIO: It's avarice, avarice that makes you sacrifice that poor innocent dove.
DOCTOR: No matter what you say, my mind's made up. I value your advice – I always have. This time, however, you will not persuade me.
PANCRAZIO: Don't be too hasty, I beg of you.
DOCTOR: Aren't you always saying: 'He who hesitates is lost'? I'm going to find Signor Zanetto. I want to see them married by tonight. Dear friend, bear with me. Goodbye. (*Goes.*)

Scene 21

PANCRAZIO, later ZANETTO.

PANCRAZIO: My hopes have been dashed. What am I to do? I daren't reveal my passion. If I do I will lose my reputation as an honourable man, and with it my only source of income. If she marries this Zanetto he'll take her to Bergamo and I shall never see her again. That cannot be. I must take drastic action. I'd rather show myself in my true colours than lose Rosaura – the woman who means more to me than anything else in the world.

ZANETTO: Signor Pancrazio, I'm that desperate.

PANCRAZIO: It's a sad fact, but death is the only consolation for such as you.

ZANETTO: I'm that keen to get wed, but nobody wants me. Every woman I meet spurns me – like I was a donkey or a dog. What's to be done?

PANCRAZIO: Ah, if you had only followed my advice, you would not be in this wretched predicament.

ZANETTO: You're about right there. I want to get away from women but I can't. I'm drawn to 'em, you see – like soapy water going down plughole.

PANCRAZIO: You weren't made for marriage.

ZANETTO: Eh?

PANCRAZIO: I'm quite certain that, if you married, you'd be the most miserable creature on earth.

ZANETTO: What shall I do then?

PANCRAZIO: Leave women alone.

ZANETTO: I can't.

PANCRAZIO: May I make a suggestion? Leave Verona at once; put an end to all this suffering.

ZANETTO: But it'll always be the same. Even in Bergamo they treats me badly.

PANCRAZIO: But what other course can you pursue?

ZANETTO: I don't know. I'm that fed up.

PANCRAZIO: If I were you, I would…

ZANETTO: Go on…

PANCRAZIO: Kill myself.
ZANETTO: Is there no other way out?
PANCRAZIO: I'm afraid not.
ZANETTO: Tha's a knowing sort of a chap. Tha must have summat for it.
PANCRAZIO: (*Aside.*) He's walking into the trap. (*Aloud.*) I'm so moved by your plight that I'm willing to part with a little of a very rare and precious powder, which I alone possess and which I guard with the utmost secrecy. I always carry some with me, in case of emergencies. I too was tormented by these urges in my youth. I don't know what I would have done without the powder. I keep it in this little box. It has cured me on numerous occasions. By repeating the dosage every five years, I have kept myself completely unscathed. One pinch should do the trick. Take it in some wine. It will make you completely indifferent to women. They will pursue you, and you can avenge yourself on them by rejecting them.
ZANETTO: For the love of God, signore, give us some.
PANCRAZIO: It's expensive...
ZANETTO: I'll pay thee well.
PANCRAZIO: I tell you what – I'm not a mercenary man – I'll let you have some free of charge. It may give you a stomach ache. You may even think you're dying. But once the pain subsides you'll feel like a new man. You'll thank me for it, I promise you.
ZANETTO: God bless thee. Give it me. Put me out of my misery.
PANCRAZIO: (*Shows ZANETTO the box.*) Here it is. Now we need some wine.
ZANETTO: I'll drink it at home.
PANCRAZIO: No, no – wait here. I'll fetch some. (*Aside.*) I can't help feeling sorry for him, but I have to kill him. He's an obstacle to my love. (*Goes into DOCTOR's house.*)
ZANETTO: I can't go on living like this. When I sees a woman I starts burning from top to toe. To Hell with 'em! Now they'll come running after me and I won't bat

an eyelid. That'll show 'em. I can't wait to get my own back on that bitch Rosaura. Here he comes. Hast tha brought wine?

PANCRAZIO: Here it is. Put the powder in.

ZANETTO: (*Puts powder in.*) Like this?

PANCRAZIO: Well done. But you must not tell anyone I gave it you.

ZANETTO: Don't fret thaself.

PANCRAZIO: Have courage.

ZANETTO: ...I'm as firm as a rock.

PANCRAZIO: And if you feel sick, put up with it.

ZANETTO: Ay. I will that.

PANCRAZIO: I'd better go – I don't want people to find out about this. If they do, they'll all be pestering me for some.

ZANETTO: Quite right.

PANCRAZIO: How we'll laugh at these women!

ZANETTO: All after me – and me? Nowt!

PANCRAZIO: Nowt.

ZANETTO: Will they cry?

PANCRAZIO: Of course. Drink.

ZANETTO: And I'll not give a damn?

PANCRAZIO: No.

ZANETTO: I'll drink it. Mud in your eye. (*Drinks.*)

PANCRAZIO: (*Aside.*) It's done. (*Goes.*)

Scene 22

ZANETTO, slowly sipping the drink; later COLUMBINA.

ZANETTO: Ugggh! What is it? Argggh! Poison! My guts is on fire. What's happening? I can't drink any more. (*Puts glass on ground.*) Oh, my! I'm dying! No – I can't be. Must be the powder. Anyroad, if I wants lasses after me, I must grin and bear it. That Signor Pancrazio said... But... Ee, I'm that poorly! I can't breathe. I can't... I didn't ought to have drunk it. I'll not take any more... Water! Water! I can't see... The ground's shaking under my feet... My

legs is giving way... My heart! My heart! Perk up, Zanetto! Women will come running after thee – and thee? Nowt...! Tha'll laugh at em... Won't that be grand... I can't stand up... I'm falling... I'm dying... (*Falls.*)

COLUMBINA: (*Comes out of house and sees ZANETTO on ground.*) What's this? Signor Zanetto on the ground? (*To ZANETTO.*) What is it? What's happened?

ZANETTO: (*Aside.*) You see! He were right!

COLUMBINA: Christ almighty! He's foaming at the mouth! He's in a bad way all right. Poor boy! I'll get help. (*Goes back in.*)

Scene 23

ZANETTO, later FLORINDO.

ZANETTO: She's fallen in love with me! And I couldn't give a damn. I... Oh... My heart's going! I'm kicking the bucket. Help! Help!

FLORINDO: (*Aside.*) Tonino. On the ground. Now for my revenge.

ZANETTO: Another one after me... (*Writhing in agony.*)

FLORINDO: (*Aside.*) It looks as though he's dying.

ZANETTO: I'm dead... I'm dead...

FLORINDO: (*Aside.*) He really is dying! (*Aloud.*) Who did this to you?

ZANETTO: I'm dying.

FLORINDO: How? What's caused it? (*Aside.*) He may be my rival, but I pity him.

ZANETTO: I drank... Women... Signor Pancrazio... I've been poisoned... Nay... To Hell wi' women... You see – I'm as firm as a rock... (*Dies.*)

FLORINDO: Poor fellow. But who could have murdered him. What's this? A glass of wine – (*Examines it.*) – cloudy. He was poisoned, alright.

Scene 24

Enter DOCTOR, BRIGHELLA, COLUMBINA. Later ROSAURA, BEATRICE, BEATRICE's SERVANT. Later ARLECCHINO.

COLUMBINA: (*To DOCTOR as they come out of house.*) Signore, come and help the poor boy.
DOCTOR: Quick – Brighella – fetch a surgeon.
FLORINDO: You're too late. Signor Zanetto is dead.
DOCTOR: Dead?
BRIGHELLA: Dead?
COLUMBINA: Dead.
ROSAURA: (*From house, to DOCTOR.*) I'm sorry, but I have to come out into the street. I thought I heard you say Signor Zanetto was dead. Is it true?
DOCTOR: I'm afraid it is...
BEATRICE: (*Coming up the street.*) Oh no, it cannot be! My beloved – dead? My darling – dead?
ARLECCHINO: What's up. Is master asleep?
BRIGHELLA: I wish he was. He's dead.
ARLECCHINO: I'm off back to Bergamo.
DOCTOR: Let's take him into the inn. It isn't right to leave him lying here.
ROSAURA: My heart's breaking!
COLUMBINA: Poor girl! You're a widow before you're a wife. (*Aside.*) Serves her right, really.
DOCTOR: (*Pointing to ZANETTO.*) Brighella.
BRIGHELLA: Arlecchino, help me carry him inside. (*To BEATRICE's SERVANT.*) And you.
BEATRICE: Poor Beatrice! What will become of you?
FLORINDO: (*Under breath to BEATRICE.*) Now Tonino's dead, is there any hope for me?
BEATRICE: I shall hate you forever.
ARLECCHINO: Steady! He may be dead but there's no need to bash him!
(*They carry ZANETTO's body into the inn.*)
ROSAURA: It's as though my heart has been torn from my breast.

BEATRICE: How did he die? What villain could have done this?
FLORINDO: He was poisoned.
DOCTOR: By whom?
FLORINDO: I don't know.
ROSAURA: Look for any clues that might help us punish this murderer.

Scene 25

Enter TONINO. Later ARLECCHINO and BEATRICE's SERVANT.

TONINO: There you are, Signora Beatrice.
DOCTOR: (*Terrified.*) What?!
BRIGHELLA: (*Terrified.*) It's the ghost of Signor Zanetto.
ROSAURA / BEATRICE : (*Together.*) He's alive!
 (*They are all bewildered and stare at one another in terror. ARLECCHINO comes out of the inn with SERVANT.*)
ARLECCHINO: Christ almighty!
TONINO: Why all this amazement?
DOCTOR: Signor Zanetto, are you alive?
TONINO: I believe so.
DOCTOR: But a moment ago you were lying there.
TONINO: I don't know what you're talking about.
BRIGHELLA: What's happening?
ARLECCHINO: Just you wait there. (*Goes into inn, comes out again.*) He's half dead, half alive! I'm off. (*Goes.*)
BRIGHELLA: (*Goes into inn, comes out again.*) It's incredible! He's dead in there and he's alive out here!
DOCTOR: Let me see for myself. (*Does likewise.*) Signor Zanetto, there's another of you in there.
TONINO: Quiet! We'll soon get to the bottom of this. (*Goes into inn.*)
ROSAURA: Please God let him be alive.
BEATRICE: He may have betrayed me but I do not wish him dead.
TONINO: (*Comes out of inn, surprised and sad.*) I have found him too late. The man lying dead in there is my brother, Zanetto.

DOCTOR: Then who are you?
TONINO: I am Tonino Bisognosi.
ROSAURA: What did he say?
DOCTOR: What portent is this?
BEATRICE: Then you are my husband…
TONINO: I am. But why did you rail at me? Why did you tear up my letter?
BEATRICE: Why did you forsake me? Why did you woo Signora Rosaura? Before my very eyes?
TONINO: I did nothing of the kind. The resemblance between my brother and me has caused a lot of confusion. But I am yours and you are mine. That's all that matters.
ROSAURA: Signor Zanetto, what about the promise you made me?
TONINO: I can't marry you both. And by the way, I'm not Zanetto.
DOCTOR: Zanetto, Tonino – whoever you are, you can still marry my daughter, if you've no objection to being a relative of mine.
TONINO: All right, I'll marry your daughter.
DOCTOR: Give me your hand.
TONINO: Where is she?
DOCTOR: Here.
TONINO: Come, come – this isn't your daughter.
DOCTOR: What do you mean?
TONINO: I know the whole story.
DOCTOR: (*To COLUMBINA.*) You little blabbermouth!
COLUMBINA: I don't know what he's talking about.
TONINO: Tell me, doctor – that medallion you found among the baby's clothes – do you still have it?
DOCTOR: With two portraits?
TONINO: Yes.
DOCTOR: Is this the one?
TONINO: It is. My father had it made when Zanetto and I were born.
DOCTOR: Since the truth's come out, I confess: Rosaura is not my daughter. She was found by a pilgrim in the

lowlands of Caldiera, between Vicenza and Verona. He told me she'd been abandoned after some bandits robbed and killed the people who were looking after her. I begged him to leave her with me. He agreed. Since then I've brought her up as if she were my own.

TONINO: This is my sister, Flaminia. My mother was taking her to my uncle, Stefanello, when they were attacked. Being a baby she was spared.

ROSAURA: Now I realise why I loved you – we're brother and sister.

TONINO: I loved you for the same reason.

BEATRICE: Thank Heavens!

FLORINDO: (*Aside.*) I've lost all hope of winning Beatrice.

TONINO: (*To ROSAURA.*) Now I understand about the letter and the...encouragement you gave me. (*To DOCTOR.*) I'm sorry, signore – I misjudged you.

DOCTOR: You've ruined me!

TONINO: How so?

DOCTOR: My brother left me an inheritance of thirty thousand ducats, for me to bring up my only daughter, Rosaura. She died. I stood to lose the money since the will stipulated that, in the event of her death, it would pass to a nephew of mine. I'd lost my daughter – I didn't want to lose my inheritance as well. I hit on the idea of replacing her with another child. As luck would have it, one came into my hands. With the help of a nurse – Columbina's mother – I was able to carry out my plan. Now that it's been exposed, my nephew will waste no time in claiming what is rightfully his.

TONINO: Who is this nephew?

DOCTOR: One Lelio.

TONINO: Not that ridiculous man who claims to be a lord?

DOCTOR: The same.

TONINO: Here he comes now. Let me deal with this.

Scene 26

LELIO: Stop, all of you! Stay away from me – I am a desperate man.
TONINO: Signor Lelio, you're wasting your time. Beatrice is to be my wife.
LELIO: I will confound the abyss. I will turn the world upside down.
TONINO: What do you want to do that for?
LELIO: I am beside myself with misery.
TONINO: There may be a remedy.
LELIO: Such as...
TONINO: Marry Signora Rosaura. Her dowry is fifteen thousand ducats now and fifteen thousand after the doctor's death.
LELIO: Thirty thousand ducats! An attractive proposition...
TONINO: Do you like the lady?
LELIO: Who wouldn't, with a dowry of thirty thousand ducats?
TONINO: Then there's no more to be said. We'll settle everything in the house. (*To ROSAURA.*) Are you content?
ROSAURA: I always do what my father tells me to.
DOCTOR: Rosaura, my child! You've saved my bacon. Signor Tonino, I'm indebted to you. Let's go in and sign the documents.
TONINO: Excellent – everyone's happy.
FLORINDO: How can I be happy? I'll never forgive myself for betraying our friendship.
TONINO: You're right to feel ashamed. But I pity you – you're in love. If you're truly sorry, I shall accept you once more as a friend.
FLORINDO: A generous offer. I accept.

Final Scene

Enter PANCRAZIO.

PANCRAZIO: (*Aside.*) What's this I see? Zanetto? Alive? I was a fool to think he'd go through with it.
DOCTOR: Signor Pancrazio – wonderful news.
PANCRAZIO: Excuse me a moment, please. (*Takes TONINO to one side.*) Did you drink all the wine I gave you?
TONINO: Are you suggesting that I – Tonino Bisognosi – am drunk?
PANCRAZIO: No. I asked if you drank the wine I gave you.
TONINO: (*Aside.*) I smell a rat. (*Aloud.*) No – I didn't.
PANCRAZIO: But, my dear Signor Zanetto, how are you going to put up with them?
TONINO: Who?
PANCRAZIO: The women who torment you.
TONINO: I don't know what you mean.
PANCRAZIO: I told you that you could be free of them by…
TONINO: Yes…?
PANCRAZIO: …taking the powder I gave you.
TONINO: Now I understand. (*To PANCRAZIO.*) Fraud! Hypocrite! You killed my brother. That's right – I'm not Zanetto, I'm Tonino. We were twins. Why did you kill him? Why?
PANCRAZIO: I don't know what you're talking about.
TONINO: You killed my brother. You wretch!
PANCRAZIO: I am incapable of such iniquity.
TONINO: Then why did you ask if I'd drunk that wine?
PANCRAZIO: What I meant to say was…were you drinking…to celebrate the wedding?
TONINO: You see – you're confused. You murdered my brother.
PANCRAZIO: This is an outrage!
DOCTOR: Signor Pancrazio is a man of the utmost integrity. I can vouch for him.

FLORINDO: I found a glass beside Zanetto. It had some cloudy wine in it.
COLUMBINA: I saw him come into the house a while ago and take a glass of wine.
FLORINDO: Let's see now...
TONINO: You'll pay for this. What have you done with the jewels?
PANCRAZIO: They're with the judge.
TONINO: Excellent! I shall recover them myself.
FLORINDO: (*Shows glass.*) Here it is.
COLUMBINA: That's the one he took.
PANCRAZIO: I am an honourable man. What's more I can prove it. Give me that glass.
(*FLORINDO gives it him.*)
DOCTOR: What did I tell you?
TONINO: (*Aside.*) If he drinks it can't be poison.
COLUMBINA: I hope it is.
PANCRAZIO: (*After drinking.*) I am dying and there is no remedy. I loved Rosaura. I could not bear the thought of her being another man's wife. So I poisoned him. I cannot go on. I am dying – dying as wickedly as I have lived. My respectability was a sham. Be warned: do not trust men who put on a show of virtue. Farewell – I am going to a desperate death. (*Exit, staggering.*)
COLUMBINA: I always said he was a wicked man.
TONINO: He's done the hangman's job for him. Oh, my poor brother – how I mourn your death... (*To ROSAURA.*) But, sister, I'm consoled by finding you.
ROSAURA: I mourn him too, but we must both be strong.
DOCTOR: Let's go in.
TONINO: With your permission, I shall bring my bride.
LELIO: And I shall follow with my goddess.
DOCTOR: Let's all go in and sign the documents. (*Aside.*) This is just what I wanted!
TONINO: With my brother's inheritance I shall clear my name in Venice. If only I could bring him back to life. I shall go to Bergamo and sort out his affairs. I thank

Fortune for helping me to find my sister and my bride. Poor Zanetto's death has resolved all the confusion that arose, in a single day, on account of the Venetian twins.

The End.

MIRANDOLINA

Characters

MIRANDOLINA
an innkeeper

RIPAFRATTA
a 'gentleman'

COUNT ALBAFIORITA

MARQUESS OF FORLIPOPOLI

ORTENSIA
an actress

DEJANIRA
an actress

FABRIZIO
a servant at the inn

RIPAFRATTA'S VALET

SUPERNUMARIES

Mirandolina received its British premiere in this translation at the Royal Lyceum Theatre, Edinburgh on 5 March 1993, with the following cast:

MIRANDOLINA, Fiona Bell

RIPAFRATTA, Paul Spence

COUNT, Bob Carr

MARQUESS, Michael Mackenzie

ORTENSIA, Nicola Crier

DEJANIRA, Mabel Aitken

FABRIZIO, Michael Mardone

RIPAFRATTA'S VALET, Eric Barlow

SUPERNUMARIES, Joe Alves, Philip Gaubin

Director, Hugh Hodgart

Designer, Gregory Smith

Lighting Designer, Nick McCall

ACT ONE

Scene 1

A room in the inn.

The MARQUESS and the COUNT are discovered.

MARQUESS: Marquesses before counts.
COUNT: This is an inn. My money's as good as yours.
MARQUESS: But I get special treatment. And I deserve it more than you.
COUNT: Oh? Why?
MARQUESS: I'm the Marquess of Forlipopoli.
COUNT: So what? I'm Count Albafiorita.
MARQUESS: How much did it cost you?
COUNT: I bought my title – you sold yours. Where does that leave us?
MARQUESS: I have a position. All I'm asking for is a little respect.
COUNT: A little? It's yours.
MARQUESS: Look, I'm here because I'm in love with the innkeeper. And if you so much as –
COUNT: Steady. Why do you think I'm here?
MARQUESS: You won't get anywhere. Not with me around.
COUNT: Oh no?
MARQUESS: I'm a man of substance. Mirandolina needs protection. My protection,
COUNT: Rubbish! She needs money. My money.
MARQUESS: I've got money.
COUNT: You could never keep up with me. I've already spent a small fortune on that woman.
MARQUESS: You're all talk.
COUNT: At least I've got something to talk about.
MARQUESS: Meaning…?
COUNT: You know damn well. You're notorious. They haven't seen tips as small as yours round here since the baby asparagus ran out.

MARQUESS: It's that Fabrizio, isn't it? He's been maligning me again. That boy is an infernal nuisance. Worse still, I think Mirandolina has her eye on him.

COUNT: I wouldn't be surprised. She's in a panic. It's six months since her father died. A young girl, trying to run an inn by herself. It's tough. Anyway, I've told her: if she marries, she gets three hundred crowns – cash down.

MARQUESS: If she does marry, I'm going to be her protector. And I…well, I know what I'll do…

COUNT: I've got an idea: why don't we each give her three hundred. Then we can take it in turns!

MARQUESS: You do what you like – I'm handling this my own way – which means: discreetly. And in the end, rank still counts for something. (*Calls.*) Service!

COUNT: (*Aside.*) Poverty and pomposity: what a combination.

FABRIZIO: (*Entering.*) You called, sir?

MARQUESS: 'SIR'! I'm a marquess, man.

FABRIZIO: Sorry.

MARQUESS: How is your mistress today?

FABRIZIO: Not too bad…oh illustrious one.

MARQUESS: She's awake, then?

FABRIZIO: Yes, oh ill–

MARQUESS: Wait a minute! What is this 'oh illustrious one' in aid of?

FABRIZIO: It's what I call this gentleman.
(*Indicates COUNT.*)

MARQUESS: 'This gentleman' is a very different animal from me.

FABRIZIO: (*Aside.*) That's true enough: he pays his bills.

MARQUESS: Send Mirandolina here. I wish to speak with her.

FABRIZIO: Will do, your wondrousness. (*About to go, when:*)

COUNT: Allow me to give a small demonstration.

MARQUESS: Demonstration?

COUNT: Of what a 'different animal' I am.
(*Ostentatiously, he hands FABRIZIO a gold coin.*)

FABRIZIO: Your SUPERBNESS!

(*He looks expectantly at MARQUESS.*)
MARQUESS: Ahem.
(*Feels in his pockets – produces a tiny coin and hands it to FABRIZIO who examines it dubiously.*)
FABRIZIO: Thanks. (*To audience.*) What a jerk. (*Goes.*)
COUNT: You just can't get it into your head, can you? Economics is everything, these days. You want respect? Well, even that has a price tag.
MARQUESS: What utter nonsense. Blue blood. That's the only commodity of any real value.
(*Enter RIPAFRATTA.*)
RIPAFRATTA: You two still rowing?
COUNT: We were debating the finer points of social precedence.
MARQUESS: (*Sarcastic.*) The Count seems to think that nobility is of no importance.
RIPAFRATTA: Want my lirasworth?
COUNT: Why not?
RIPAFRATTA: Status doesn't mean a thing these days. All boils down to cash. Hard cash.
COUNT: My point exactly.
MARQUESS: Couldn't we change the subject?
RIPAFRATTA: What got you onto it in the first place?
COUNT: We're both in love with Mirandolina. I'm trying to get her for cash. He's trying to get her on tick. Only he calls it 'nobility'.
MARQUESS: He doesn't understand. I'm protecting her.
COUNT: That's bilge. I spend more on her in a day than he does in a month.
RIPAFRATTA: Money down the drain. I wouldn't spend a florin on that woman.
COUNT / MARIO: EH?
RIPAFRATTA: Well, really – I can't think of anything less worth arguing about. A female's upset you? A female's ruffled your feathers? A FEMALE! It's absurd! I'll never fall into that trap. Brrrr! Women! Never been in love with one. Never even liked one. You want my opinion? A woman's like a bad bout of flu: exhausting, and hard to shake off.

COUNT: True enough. But you must admit, she's got something has our little innkeeper.
MARQUESS: Quite so. Why else would I be after her?
RIPAFRATTA: Don't make me laugh. What's she got that other women haven't?
MARQUESS: It's hard to define – an air of…nobility – that's it.
COUNT: Her beauty – her wit – the sheer elegance of her. No, I'm sorry – she's exquisite.
RIPAFRATTA: I've never heard such rubbish. I've been here three days and I haven't felt so much as a twitch.
COUNT: You can't have had your eyes open.
RIPAFRATTA: I've seen her. She's a woman. So what?
MARQUESS: You're wrong. She's more than that. She has a unique blend of sweetness and dignity. I've known my share of well-bred women, and I've never seen anything to touch her.
COUNT: And I'll tell you something else: six months' solid courtship – not to mention a vast capital outlay – and I haven't managed to lay a finger on her. Now, if that's not unique I don't know what is.
RIPAFRATTA: Oh, dear; oh, dear! You haven't fallen for that old one!
COUNT: I take it you've never been in love?
RIPAFRATTA: Never. My friends keep trying to marry me off, but I haven't succumbed and I don't intend to start now. Give me a good hunting dog, any day.
(*Enter MIRANDOLINA.*)
MIRANDOLINA: Good day, gentlemen. I was told one of you wanted to see me.
MARQUESS: I did. But not here.
MIRANDOLINA: Where would you like me, then?
MARQUESS: In my room.
MIRANDOLINA: I'll send a chamber-maid. What do you need?
MARQUESS: I'll let you know. (*Aside, to RIPAFRATTA.*) You see that? Such tact! Such delicacy!
MIRANDOLINA: (*To COUNT.*) Anything I can do for you?

COUNT: Yes. Try these on.
(*Produces earrings.*)
MIRANDOLINA: Hmmm. They're lovely.
COUNT: A mere trifle. Diamond, of course.
MIRANDOLINA: I can see that.
COUNT: They're yours.
RIPAFRATTA: (*Aside, to COUNT.*) You're mad!
MIRANDOLINA: I couldn't… (*Makes to give them back.*)
MARQUESS: (*Scrutinising them.*) I've seen better.
COUNT: Please – I insist.
RIPAFRATTA: (*Aside to COUNT.*) For God's sake man!
MIRANDOLINA: No really – this is too much.
COUNT: If you don't take them, I shall be most offended.
MIRANDOLINA: Well, since you put it that way… (*Takes them.*)
RIPAFRATTA: (*To audience.*) I'm not seeing this!
COUNT: (*To RIPAFRATTA.*) Isn't she delightful? So down-to-earth.
RIPAFRATTA: (*Aside to COUNT.*) Delightful! She'll eat you up and spit out the pips.
MARQUESS: I've never seen such revolting ostentation: giving a woman diamonds – in front of everyone.
(*Dramatic.*) Mirandolina, I must speak with you.
MIRANDOLINA: I'm all ears.
MARQUESS: (*Fishes in pockets – finds nothing.*) Yes! Well! I – er…
MIRANDOLINA: Gentlemen, if there's nothing else you need… (*Going.*)
RIPAFRATTA: Wait a minute: that linen you sent up yesterday – it's filthy.
MIRANDOLINA: Ask nicely, and I'll have it changed.
RIPAFRATTA: 'Ask nicely'! 'ASK NICELY'! Who's paying the bill?
COUNT: (*To MIRANDOLINA.*) Don't mind him – he just hates women.
RIPAFRATTA: No, go on – mind me. I want you to mind me.
MIRANDOLINA: (*Interested.*) But what have we done to make you hate us?

GOLDONI

RIPAFRATTA: Never mind that – just get my linen changed.
(RIPAFRATTA bows to COUNT and MARQUESS and goes.)
MIRANDOLINA: I think I'm going to have to throw him out. Pity: business isn't too good at the moment.
COUNT: You won't lose by it. I'll see to that. *(Pats purse.)*
MARQUESS: And if he gives you any trouble, you can rely on my protection.
COUNT: *(Aside, to MIRANDOLINA.)* Get rid of our friend here, and I'll cover that too.
MIRANDOLINA: Gentlemen, really! I'm overwhelmed. All the same, I think I can manage on my own.
(Enter FABRIZIO.)
FABRIZIO: *(To COUNT.)* Sir – someone's asking for you.
COUNT: Who?
FABRIZIO: I think he's a jeweller. *(Aside, to MIRANDOLINA.)* You'd better make yourself scarce. *(Goes.)*
COUNT: Of course: he's bringing me a little something to go with those earrings.
MIRANDOLINA: Now really, Count...
COUNT: It's the least I can do. I'll see you later, then.
(Bows cursorily to MARQUESS and goes.)
MARQUESS: To Hell with him and his 'little somethings'.
MIRANDOLINA: *(Mimicking MARQUESS.)* Yes, isn't he a bore?
MARQUESS: As if a woman of your calibre is interested in diamonds. I don't know how you put up with it.
MIRANDOLINA: Oh, I manage.
MARQUESS: Well you won't get that sort of treatment from me, I can assure you.
MIRANDOLINA: My dear Marquess, I wouldn't expect it from you – not for one minute.
MARQUESS: But, if there's anything else...
MIRANDOLINA: Such as?
MARQUESS: Name it.
MIRANDOLINA: All right. Now let me see...
MARQUESS: My God, but you're beautiful!
MIRANDOLINA: Thanks.

MARQUESS: I could almost curse my rank sometimes.
MIRANDOLINA: How come?
MARQUESS: Well, there are times when I envy the Count.
MIRANDOLINA: Because he's rich?
MARQUESS: Pah! Of course not. But if I were only a paltry Count, like him... I'd...
MIRANDOLINA: Go on...
MARQUESS: Dammit, I'd marry you! (*Goes.*)
MIRANDOLINA: Charming! 'Dammit, I'd marry you'! Who does he think he is? Imagine being his wife. I like to eat now and then, for a start. God knows, if I'd married everyone who wanted me, there'd be a husband in every room by now. I'm lovely – and they love me. What can I do? They pay the bill, they propose, I send them packing. It's practically a daily occurrence. That oaf Ripafratta's about the first one who hasn't gone gooey-eyed at the sight of me... Well, perhaps I'm exaggerating. But it is rather irritating, all the same. He hates women, does he? Why? What's wrong with him? Nothing I can't fix, at any rate! I like a challenge. It's a weakness of mine, you see: I have to make everyone adore me. I thrive on it. And the count? He'll have to look elsewhere. Money has its uses, of course – but it's not everything. It's not as if you can't be independent and respectable at the same time. Besides, I've got a mission: to convince the doubters that women really are the best idea Nature ever came up with.
(*Enter FABRIZIO.*)
FABRIZIO: Ummm...
MIRANDOLINA: What is it now?
FABRIZIO: That prat in room five is banging on about his linen. He says it's dirty.
MIRANDOLINA: I know, I know. I'm dealing with it.
FABRIZIO: Well, could you come with me? I'm a bit scared of him.
MIRANDOLINA: Don't worry. I'll go myself.
FABRIZIO: Are you sure that's wise?
MIRANDOLINA: I said I'll see to it.

FABRIZIO: You don't er...you're not er...by any chance...?
MIRANDOLINA: None of your business.
FABRIZIO: (*Aside.*) I knew it. I haven't got a hope. Toying with me – that's what she's doing.
MIRANDOLINA: (*Aside.*) The poor boy's insanely jealous. He's besotted with me, you see. Still, it makes him work harder.
FABRIZIO: Anyway, I thought I was in charge of the linen department.
MIRANDOLINA: You haven't got the hang of it yet.
FABRIZIO: And that's not all I haven't got – right?
MIRANDOLINA: Watch it.
FABRIZIO: Alright, alright, keep your hair on. And you can find yourself a new dogsbody, while you're at it.
MIRANDOLINA: Hey! What's got into you?
FABRIZIO: Remember what your father (*Crosses himself.*) said before he died?
MIRANDOLINA: I will do, when I decide to get married. Not before.
FABRIZIO: Servants have feelings too, you know.
MIRANDOLINA: For God's sake, do you really think these men interest me? They're in here one minute and out the next. If I'm friendly with them, it's strictly business. I don't need earrings, and as for making love – one's more than enough.* So I repeat: dying words can wait. Meanwhile, if you keep your end up, you won't lose by it. That's my problem, really: I'm appreciative, but I'm not appreciated. (*Heaves a sigh and goes.*)
FABRIZIO: Did you follow all that? I'm not sure I did. But my God, she's a demanding woman! (*Pause.*) Sometimes she seems to want me, other times I'm not sure. What exactly is she up to? Is she really such an easy lay? Time

* I think one's reading of this scene is crucial. Are Fabrizio and Mirandolina already sleeping together when the play opens, as some critics believe? Not that the ambiguity need be resolved, but it should definitely be there. If they are sleeping together, Mirandolina becomes a much more interesting character for a modern audience – an independent woman who is keeping her options open. (RB)

will tell. Everything I've ever done was aimed at pleasing her. Relax – that's the answer. Don't try and chase everything down. The customers come and go. I can go on indefinitely. Time's on my side, alright. (*Goes.*)
(*Enter RIPAFRATTA and SERVANT.*)
SERVANT: Letter for you, sir.
RIPAFRATTA: (*Takes it.*) Bring me a cup of coffee.
(*SERVANT goes.*)
(*Opens letter, reads.*) 'Siena – January First 1753. Dear Ripafratta, As a devoted friend, I would advise you to return home as soon as possible. Count d'Emilio is dead...' (Shame – nice fellow – not to worry.) '...He leaves behind him a daughter of marriageable age and a fortune of 150,000 crowns. I think I speak on behalf of all your devoted friends, when I say how delighted we should be if you could secure such a lucrative match... et cetera et cetera.' Well, they'd better drop that idea. They know my views on marriage. But they will keep on at me. 150,000 crowns... Hm... Bah! A quiet life – that's all I want. Once you're married, a sum like that looks like chicken feed.
(*Enter MARQUESS.*)
MARQUESS: I hope I'm not disturbing you...
RIPAFRATTA: (*Gruffly.*) Be my guest.
MARQUESS: At least you and I can converse on equal terms. That wretched count isn't worthy to talk to the likes of us.
(*Silence.*)
RIPAFRATTA: What made you do it, then?
MARQUESS: I'm sorry...?
RIPAFRATTA: Fall in love with that woman.
MARQUESS: I can't explain it. She's bewitched me.
RIPAFRATTA: Rubbish! Just stay away from her and you'll be over it in a week.
(*SERVANT returns with coffee.*)
And another one for my friend here.
SERVANT: Sorry, sir – this was the last cup. (*Goes.*)
RIPAFRATTA: (*Grudging.*) I suppose you'd better have mine.

MARQUESS: You're too kind. (*Between dainty sips.*) Nothing seems to be going my way at the moment. My steward's giving me a hell of a time. He was supposed to send me an extra twenty, and I haven't seen hide nor hair of them.
RIPAFRATTA: (*Aside.*) Wait for it.
MARQUESS: To be honest, I'm in a bit of a tight spot…
RIPAFRATTA: You don't say.
MARQUESS: Fate's against me, you see. It's the story of my life.
RIPAFRATTA: My heart's bleeding already. (*Pause.*)
MARQUESS: Look, I was wondering – could you help me out? It would only be for a week – at the most…
RIPAFRATTA: I-would-if-I-could-but-I-can't.
MARQUESS: You mean to say…
RIPAFRATTA: Broke. See for yourself.
(*He empties his purse. One tiny coin drops out. MARQUESS collects it (a Pavlovian reaction).*)
MARQUESS: Don't worry: this'll do to be going on with. And now, if you'll excuse me… (*Goes.*)
RIPAFRATTA: The cheek of the man!
(*He peers into the coffee cup – it's empty.
Enter MIRANDOLINA, with linen on her arm. She comes forward with studied coyness.*)
MIRANDOLINA: Ahem – Signor Ripafratta…
RIPAFRATTA: What is it?
MIRANDOLINA: (*Closer now.*) I brought the fresh linen.
RIPAFRATTA: Good. Put it there. (*Points to table.*)
MIRANDOLINA: (*Hurt.*) It's cambric. Ten florins a yard. Look…
RIPAFRATTA: What am I? The Pope? I just asked for some linen.
MIRANDOLINA: But I save this for my best customers…
RIPAFRATTA: I've heard that one before.
MIRANDOLINA: Just feel that. (*Offers cloth.*)
RIPAFRATTA: (*Feels; sarcastic.*) Heaven.
MIRANDOLINA: I'm saving all my cambric for you.
RIPAFRATTA: (*Aside.*) She's attentive – I'll give her that. (*Aloud.*) Look: don't trouble yourself on my account. My servant can deal with the linen.

MIRANDOLINA: But it's no trouble, really. Nothing but the best for a man of your ilk.
RIPAFRATTA: Alright, alright – that'll be all.
MIRANDOLINA: I'll just put it in the cupboard.
RIPAFRATTA: Wherever you like.
MIRANDOLINA: (*Aside.*) This is going to be a tough one. (*Aloud.*) What would you like for your supper?
RIPAFRATTA: Whatever's going.
MIRANDOLINA: Anything special, though?
RIPAFRATTA: Ask my servant about it, would you?
MIRANDOLINA: Do you like game?
RIPAFRATTA: Listen, if you think I'm like the other two...
MIRANDOLINA: Aren't they a pain? You want room service – they want servicing in their rooms.
RIPAFRATTA: But you do lead them on...
MIRANDOLINA: I have to earn a living. I laugh my head off behind their backs, I can tell you. You know, they actually think they're getting somewhere.
RIPAFRATTA: I must say, I like your frankness.
MIRANDOLINA: It's my best feature.
RIPAFRATTA: But I don't like your flirtatiousness.
MIRANDOLINA: Flirtatiousness! Look at me: I'm not all that young, or beautiful. I've had offers, yes – but I've always held out. Freedom is priceless – I really believe that.
RIPAFRATTA: Funny! So do I.
MIRANDOLINA: But people are so eager to throw it away. I've never understood why.
RIPAFRATTA: You won't catch me doing that.
MIRANDOLINA: Then you're not married?
RIPAFRATTA: Good God no!
MIRANDOLINA: I'm glad to hear it. Women... But I shouldn't malign my own sex...
RIPAFRATTA: Please go on. I've never heard a female talk like this before.
MIRANDOLINA: I'll say this much: I keep an inn – I've seen it all – and I can understand your attitude.
RIPAFRATTA: (*Aside.*) This woman's incredible!

MIRANDOLINA: But I'd better be getting on... (*Makes to go.*)
RIPAFRATTA: What's the hurry?
MIRANDOLINA: Aren't I in your way?
RIPAFRATTA: On the contrary, I was enjoying myself.
MIRANDOLINA: That's what I mean, you see: with the others, I hang around for a while, we swap a few jokes, and in no time they start getting the wrong idea.
RIPAFRATTA: You can't help being attractive.
MIRANDOLINA: Kind of you to say so. (*Curtsies.*)
RIPAFRATTA: The other two are besotted with you.
MIRANDOLINA: So it would seem. Pathetic, isn't it?
RIPAFRATTA: Absurd.
MIRANDOLINA: That's the spirit.
RIPAFRATTA: It's human weakness, I'm afraid. You can't blame them, really.
MIRANDOLINA: I couldn't agree more. Put it there. (*Offers hand.*)
RIPAFRATTA: What for?
MIRANDOLINA: It's clean.
RIPAFRATTA: Alright, then.
MIRANDOLINA: At last, I've shaken hands with a sensible man.
RIPAFRATTA: That'll do. (*Withdraws hand.*)
MIRANDOLINA: You see! Most men would immediately have assumed they were in business, and made a crude pass at me. That's why I never let them get near me. You've no idea what a relief it is to be able to talk freely to a man – I mean without the whole thing turning into a sort of battle of wits. But I'm being impertinent. What can I do for you? Just say the word and it's yours.
RIPAFRATTA: Really? And what makes me so special?
MIRANDOLINA: Haven't I just explained?
RIPAFRATTA: (*Aside.*) What exactly is this woman's game?
MIRANDOLINA: (*Aside.*) How am I doing?
RIPAFRATTA: Look – don't let me keep you...
MIRANDOLINA Yes – I suppose I'd better be getting on. Chores! Don't you just love them? Who needs men? If you want anything, I'll send Fabrizio up with it.

RIPAFRATTA: You can bring it yourself if you like.
MIRANDOLINA For you, anything.
RIPAFRATTA Really?
MIRANDOLINA Oh, come on – you must see that I'm fond of you.
RIPAFRATTA: Me!
MIRANDOLINA: Yes you: because you obviously know about life. And because you're not going to fall in love with me. (*Aside.*) I give him a couple of hours. (*Goes.*)
RIPAFRATTA: It's not a trick. My God, what a woman! So straightforward! How often do you meet one like that? Still, it's no reason to fall in love. Alright, she's fun to be with – but give up my freedom...? Never! NEVER! (*Goes.*)

Scene 2

Another room in the inn.

FABRIZIO, DEJANIRA and ORTENSIA discovered.

FABRIZIO: I hope the rooms are to your liking, your ladyships.
ORTENSIA: (*Acting lofty.*) They'll do. Are you the innkeeper, or a servant?
FABRIZIO: A servant, your ladyship. (*Bows low.*)
DEJANIRA: (*Sotto voce to ORTENSIA.*) For once in your life, someone's treating you like a lady.
ORTENSIA: (*Likewise.*) Shhh! I'm enjoying it. (*Aloud.*) I say – my good man...
FABRIZIO: Your ladyship?
ORTENSIA: Send the landlady here – immediately.
FABRIZIO: She'll be right with you, your ladyship. (*Goes.*)
ORTENSIA: Can you beat that? He thinks we're aristos.
DEJANIRA: It won't do us any harm.
ORTENSIA: It'll push the prices up...
DEJANIRA: I can handle that. I've been around.
ORTENSIA: All the same, I don't like it.
DEJANIRA: Don't be such a wimp. We're actresses. We've been playing duchesses and countesses for years.

GOLDONI

ORTENSIA: True. But then we only had to fool the punters – this is an inn.
DEJANIRA: Inn schminn.
ORTENSIA: And what happens when the others turn up?
DEJANIRA: They'll be lucky to get here tonight.
ORTENSIA: Thank God we came by coach.
DEJANIRA: Yes. That was our best scam yet.
ORTENSIA: And we'd never have pulled it off, if I hadn't…
FABRIZIO: (*Re-entering.*) The landlady is on her way.
ORTENSIA: (*As before.*) Good! Splendid!
FABRIZIO: And if there's anything you want, I'm at your service. Please – give me an order!
ORTENSIA: My dear boy – calm yourself. I'll think of something in due course.
DEJANIRA: (*To audience.*) She's always been good at these parts.
FABRIZIO: There are one or two formalities… (*Produces pen and small book.*)
DEJANIRA: (*Aside.*) Oh dear.
ORTENSIA: What's this?
FABRIZIO: I'll need your home address, rank and nationality, I'm afraid.
DEJANIRA: (*Aside to ORTENSIA.*) So much for blue blood.
ORTENSIA: I dare say a lot of punt…people give false names?
FABRIZIO: That's none of my business, your ladyship. I just write them down.
ORTENSIA: Baroness Ortensia del Poggio, from Palermo.
FABRIZIO: Palermo! You're a Sicilian. (*Aside.*) Sex and violence! (*Writes.*) And your ladyship…?
DEJANIRA: Ah! Yes! Well… (*Aside to ORTENSIA.*) Who the hell am I?
ORTENSIA: No need to be so coy, countess.
DEJANIRA: Of course not!
FABRIZIO: I'm waiting…
DEJANIRA: Countess Dejanira…
FABRIZIO: Di what?

DEJANIRA: (*To ORTENSIA.*) Di what?
ORTENSIA: Dal Sole. And she's from Rome.
FABRIZIO: Fine. Sorry for any inconvenience. (*Aside.*) I'll bleed them dry! (*Goes.*)
DEJANIRA: My dear baroness, at your service…
ORTENSIA: On the contrary, my dear countess…
(*A curtseying match is under way as MIRANDOLINA enters.*)
DEJANIRA: Madam, you flatter me.
ORTENSLA: Nonsense.
MIRANDOLINA: (*Aside.*) What the hell's going on here?
DEJANIRA: It's no use – I've got to laugh!
ORTENSIA: Look out – here she comes.
MIRANDOLINA: Ladies – what can I do for you?
ORTENSIA: Ah – there you are at last.
DEJANIRA: You must be the landlady. Delighted.
MIRANDOLINA: May I have the honour of kissing your ladyship's hand?
DEJANIRA: Of course. Of course. (*Offers it.*)
(*DEJANIRA suppresses an outburst of laughter, then snaps back into total seriousness.*)
MIRANDOLINA: And yours…?
DEJANIRA: Must you?
MIRANDOLINA: Oh, please…
DEJANIRA: (*In dire trouble now.*) Here you are, then. (*Offers it.*)
MIRANDOLINA: Something funny – 'your ladyship'?
ORTENSIA: She's always doing this. She can't help herself. They call her the laughing countess.
MIRANDOLINA: (*Aside.*) If she's a countess, I'm Lucretia Borgia.
ORTENSIA: I suppose we shall have to discuss money.
MIRANDOLINA: I'll see your valets about that.
ORTENSIA: Our valets…
DEJANIRA: You can't see them – they're not here.
MIRANDOLINA: Why not?
ORTENSIA: My husband – the count…
MIRANDOLINA: Baron.
ORTENSIA: Baron…

MIRANDOLINA: What about him?
(*DEJANIRA is in difficulty once more.*)
She's off again.
ORTENSIA: It's my husband – he's a very witty man – mention his name and she cracks up.
MIRANDOLINA: And you don't?
ORTENSIA: I'm married to him.
MIRANDOLINA: True. Go on.
ORTENSIA: Where were we?
MIRANDOLINA: You tell me.
ORTENSIA: Weelll…
MIRANDOLINA: Why not just drop it?
ORTENSIA: Drop what?
MIRANDOLINA: Come on – you're no more a baroness than I am. Admit it. I won't let on.
DEJANIRA: Are you suggesting…?
MIRANDOLINA: Oh, come on!
DEJANIRA: (*With evident relief, and in her normal voice.*) Alright, then.
(*ORTENSIA is gazing at DEJANIRA in horror.*)
MIRANDOLINA: (*To DEJANIRA.*) Good for you. A bit of honesty never hurt anyone.
ORTENSIA: (*Capitulating.*) It's just harmless fun.
MIRANDOLINA: Don't worry – I'm not about to spoil it. And you're to treat this place as if it were your own home.
DEJANIRA: Thanks.
MIRANDOLINA: (*Sees MARQUESS approaching.*) Oh dear.
ORTENSIA: What's up?
MIRANDOLINA: I shudder to think! It's the Marquess of Forlipopoli.
ORTENSIA: Is he rich?
MIRANDOLINA: Funny you should ask that…
MARQUESS: (*Interrupting.*) Ladies (*With an expansive bow.*) – I trust I'm not disturbing you?
DEJIRA / ORTENSIA: (*Resuming their act.*) Not at all.
MARQUESS: (*To MIRANDOLINA.*) Who are they?
MIRANDOLINA: Two of my most illustrious guests, your excellency.

ORTENSIA: (*Aside to DEJANIRA.*) Hear that? 'Your Excellency'.
MARQUESS: Whom do I have the honour...?
MIRANDOLINA: Allow me to introduce: Baroness Ortensia del Poggio and Countess Dejanira dal Sole.
MARQUESS: Enchanted.
ORTENSIA: (*Already coming on strong.*) The pleasure's entirely mine – er...?
MARQUESS: The Marquess of Forlipopoli, at your service. I assure you, you couldn't have chosen a better inn. The landlady is a most remarkable woman.
MIRANDOLINA: His Excellency has graciously offered me his protection.
MARQUESS: That's right – I'm protecting her. I protect everyone who comes to this inn. I'm at your service, if you need me.
ORTENSIA: You do me too much honour, sir.
DEJANIRA: I should consider myself fortunate indeed if, in your infinite...well thanks, anyway.
(*The MARQUESS produces a splendid silk handkerchief, spreads it with a flourish and pretends to wipe his forehead.*)
MIRANDOLINA: What a wonderful handkerchief.
MARQUESS: You really think so?
MIRANDOLINA: You have excellent taste.
MARQUESS: (*To ORTENSIA.*) Did you ever see one quite like it?
ORTENSIA: It's glorious. Simply glorious.
MARQUESS: English, you know. I got it in London.
DEJANIRA: Jolly nice too.
MARQUESS: Thank you. Now, that count – he's got no idea about the value of money. He spends like a man possessed, and what on? Dross. Utter dross.
MIRANDOLINA: His excellency, on the other hand, has impeccable taste.
MARQUESS: (*With a flourish, to MIRANDOLINA.*) Take it!
MIRANDOLINA: I'm sorry?
MARQUESS: The handkerchief. It's yours.
MIRANDOLINA: I couldn't...

MARQUESS: But I insist.
MIRANDOLINA: No – really…
MARQUESS: Accept it, I implore you.
MIRANDOLINA: You're too kind. (*Takes it.*)
DEJANIRA: (*Under breath to ORTENSIA.*) She'll go far.
MIRANDOLINA: (*To MARQUESS.*) Your first gift to me. I don't know what to say… (*Pretends to be on the verge of tears.*)
DEJANIRA: (*To MARQUESS.*) Would you care to join us for lunch?
MARQUESS: By all means. (*Aside, to MIRANDOLINA.*) Don't be alarmed. I am yours – and only yours.
MIRANDOLINA: Oh good.
(*Enter COUNT.*)
COUNT: Mirandolina – I've been looking for you.
MIRANDOLINA: I was attending to these ladies.
COUNT: Ladies? I see no ladies.
(*MIRANDOLINA indicates the 'ladies'.*)
COUNT: (*Sceptical.*) Hmmm… Your servant.
(*A cursory bow – they curtsey and simper back.*)
MARQUESS: (*Aside, to MIRANDOLINA.*) Show him the handkerchief.
MIRANDOLINA: Oh, yes. Look at this, count. Isn't it lovely? A present from the marquess here.
COUNT: Beats a kick in the head, I suppose.
MARQUESS: A mere bagatelle.
COUNT: (*To MIRANDOLINA.*) I have to speak to you – (*To ORTENSIA and DEJANIRA.*) – with your permission… (*Draws MIRANDOLINA aside.*) What do you think of that? (*Shows her a diamond.*)
MIRANDOLINA: It's gorgeous.
(*ORTENSIA and DEJANIRA are watching all this. They begin to whisper together. MARQUESS is flummoxed again.*)
It's even nicer than the earrings.
COUNT: Go on, then – take it.
MIRANDOLINA: Out of the question.
COUNT: But I…
MIRANDOLINA: Now, you're not to insist.

COUNT: But I do insist.
MIRANDOLINA: Oh, you are the limit! (*Takes it.*)
(*ORTENSIA and DEJANIRA flabbergasted, MARQUESS on the verge of tears – reaches for his handkerchief, then realises he's given it to MIRANDOLINA.*)
(*To MARQUESS.*) Isn't it wonderful?
MARQUESS: It's not bad. But the handker…
COUNT: She can use that to polish it with.
MARQUESS: You should be ashamed of yourself, flaunting your money like that.
COUNT: And you're so discreet, of course.
MIRANDOLINA: (*Aside.*) Getting caught in the crossfire can be quite lucrative.
MARQUESS: (*To ORTENSIA and DEJANIRA.*) Don't forget – you're lunching with me.
DEJANIRA / ORTENSIA: (*Ignoring him, to COUNT.*) I don't think we've been introduced.
COUNT: Count Albafiorita, at your service.
DEJANIRA: I know the name, of course.
ORTENSIA: Are you staying here?
COUNT: I am.
ORTENSIA: Is it lively?
COUNT: Very.
MARQUESS: Ladies, you must be tired of standing – can I escort you to your room?
ORTENSIA: (*Abrupt.*) No thanks. (*Turning back to COUNT.*) Where are you from, count?
COUNT: Naples.
ORTENSIA: I don't believe it. We're practically neighbours. I'm from Palermo.
DEJANIRA: I'm from Rome. But I've been to Naples.
COUNT: Are you travelling alone?
MARQUESS: They're with me now, actually.
ORTENSIA: Quite alone.
COUNT: Then you'll join me for lunch?
DEJANIRA: We'd love to.
COUNT: (*To MIRANDOLINA.*) Have lunch for three brought up.

MARQUESS: But they...but I...
COUNT: I'm afraid I've only got three chairs.
MARQUESS: But you can't...
ORTENSIA: Let's go. (*Offers arm to COUNT. To MARQUESS.*) You can eat with us another time.
DEJANIRA: (*To MARQUESS.*) And if you find another handkerchief, do let me know.
MARQUESS: I'll pay you back for this.
COUNT: What's wrong?
MARQUESS: I'm a man of substance. I won't be treated like this. (*Indicating DEJANIRA.*) She wants a handkerchief, does she? Well she's not having one. (*To MIRANDOLINA, indicating the handkerchief.*) Look after it, won't you? It's a rarity, you know – unlike certain baubles I could mention. (*Goes.*)
MIRANDOLINA: What a weird man!
COUNT: You don't mind my lunching with these two?
MIRANDOLINA: Not at all.
COUNT: I'm only doing it for you. After all, it enhances the appeal of the place. What's mine is yours. You know that.

(*He escorts the ladies out.*)

MIRANDOLINA: It'll take a bigger jewel than this to make me love him. If I opted for one of them, it would certainly be the one who spends more. But as it is – well, I've got enough on my plate already. I'm going to make that woman-hater love me if it's the last thing I do. I'm not giving up a pleasure like that easily. I may not be in the same class as those two actresses, but I can but try. What's more, they'll keep the Count and the Marquess busy, which leaves my hands free for Ripafratta. He's bound to succumb eventually. Who can resist a woman, when she gets a chance to use her skills? The only safe course is to run away. If you stay – if you listen – you haven't got a cat's chance in Hell. (*Goes.*)

End of Act One.

ACT TWO

Scene 1

RIPAFRATTA's room, with table laid for lunch, and chairs. RIPAFRATTA and SERVANT are discovered, the former walking up and down, reading. FABRIZIO enters, and places lunch on the table.

FABRIZIO: (*To SERVANT.*) You can tell your master the soup's ready.
SERVANT: Tell him yourself.
FABRIZIO: (*Eyes RIPAFRATTA anxiously.*) I'd rather you did it.
SERVANT: He won't bite. (*But to RIPAFRATTA.*) Soup's ready, sir – if you'd care to…
(*RIPAFRATTA puts book down and seats himself at table.*)
RIPAFRATTA: (*To SERVANT, as he starts in.*) Lunch is early today.
SERVANT: The landlady's instructions, sir. You were to be served first. It put the count's nose out of joint, I can tell you.
RIPAFRATTA: Hm. Kind of her.
SERVANT: She's a marvel, sir. I've been around, and I've not seen a landlady to touch her.
RIPAFRATTA: (*Interested.*) You think so?
SERVANT: If it weren't for you, sir – no offence – I'd work for her like a shot.
RIPAFRATTA: Then you're a bigger fool than I took you for.
(*He hands SERVANT the soup bowl. SERVANT places clean one in front of him.*)
SERVANT: I mean it, sir. I'd follow her about like a dog.
RIPAFRATTA: She's dangerous. I'm getting out of here. We leave for Livorno in the morning.
SERVANT: That still gives her the rest of today, sir.
RIPAFRATTA: Just let her try it.

(*The SERVANT goes out.*)
RIPAFRATTA: (*Alone.*) That woman's a witch. Well she's not going to cast a spell on me. Let her do her worst while she's got the chance. She'll soon find out what sort of man she's dealing with. It'll take more than her to convert me to women.
(*SERVANT re-enters with tray, on which are plate, sauceboat, and a dish of chicken.*)
SERVANT: (*Re-entering.*) She's worried you mightn't like the chicken, sir, so she's sending up a pigeon as well. (*Serves him.*)
RIPAFRATTA: It's all the same to me. What's that?
SERVANT: A sauce, sir. She made it herself. (*Pours.*)
RIPAFRATTA: (*Tasting.*) Not bad. Not bad at all. Thank her for me, would you?
SERVANT: Right you are, sir.
RIPAFRATTA: Well, don't just stand there – do it now!
SERVANT: Now? (*Aside.*) It's a miracle! (*Goes.*)
(*RIPAFRATTA eyes the sauce warily, but can't resist trying some more.*)
RIPAFRATTA: Am I dreaming? If she goes on cooking like this, she'll never be short of custom. Clean linen, excellent table…and what's more, she's got real style. Know what I like best? Her honesty. That's what I can't stand about women, you see – all that affectation. But in this case…
SERVANT: (*Re-entering.*) She said to thank you for being so generous as to overlook her limitations, sir.
RIPAFRATTA: Alright, cut it out.
SERVANT: The pigeon's on its way.
RIPAFRATTA: Pour me some wine.
SERVANT: Right you are, sir. (*Goes to fetch wine.*)
RIPAFRATTA: I may as well be nice to her while I'm here. After all, she's gone to so much trouble. That's right: I'll behave myself while I'm here, and get out first thing in the morning. (*SERVANT pours wine.*) Has the count gone to lunch?
SERVANT: Yes, sir. With two ladies.

RIPAFRATTA: Ladies? Who are they?
SERVANT: I've no idea, sir. They just arrived.
RIPAFRATTA: Does he know them?
SERVANT: I don't think so. But as soon as he saw them, he invited them to lunch.
RIPAFRATTA: Fool! Damned fool! All that feminine tittle-tattle – wreaks havoc with the digestion. What about the marquess?
SERVANT: He seems to have disappeared, sir.
(*MIRANDOLINA appears in the doorway, carrying a dish.*)
MIRANDOLINA: May I come in?
RIPAFRATTA: (*To SERVANT.*) Take that dish from her.
MIRANDOLINA: Please – let me have the honour of serving you myself.
RIPAFRATTA: Out of the question.
MIRANDOLINA: But I insist. After all, what am I here for?
RIPAFRATTA: (*Aside.*) Submissiveness. How often do you see that in a woman these days?
MIRANDOLINA: (*While serving him.*) Mind you, I don't serve everyone myself. There tend to be…hazards, if you take my meaning. But I'll make an exception for you.
RIPAFRATTA: You will? Thank you.
MIRANDOLINA: How's your pigeon?
RIPAFRATTA: Pardon? Oh! (*Tastes.*) Wonderful. (*Aside.*) We leave at dawn.
MIRANDOLINA: It's a little speciality of mine.
(*At which, he chokes on a mouthful.*)
RIPAFRATTA: (*To SERVANT.*) Drink!
(*SERVANT brings wine to table. MIRANDOLINA glances at it.*)
MIRANDOLINA: Ah, the burgundy – an excellent choice.
RIPAFRATTA: You know about wine, too?
MIRANDOLINA: I'm not a bad judge.
RIPAFRATTA: (*Sinking fast now.*) Not such a good judge of people, though, or you wouldn't be wasting your time on the likes of me.
MIRANDOLINA: Don't be silly.

RIPAFRATTA: No, really – it's ridiculous. (*MIRANDOLINA heaves sigh.*) What was that in aid of?
MIRANDOLINA: I was just thinking...
RIPAFRATTA: Go on...
MIRANDOLINA: Well, it's not often I get a customer who really appreciates me.
RIPAFRATTA: I find that hard to believe.
MIRANDOLINA: It's true.
RIPAFRATTA: You think I'm a bear, don't you. Well, I'm not.
MIRANDOLINA: I'm not sure I follow you.
RIPAFRATTA: Never mind. Here's to you. (*Drinks.*) Ah! Delicious!
MIRANDOLINA: You can't beat a good burgundy.
RIPAFRATTA: Would you like some? (*Offers.*)
MIRANDOLINA: I don't know if I should...
RIPAFRATTA: Nonsense. (*To SERVANT.*) Another glass.
MIRANDOLINA: Oh, that's alright – I'll make do with yours. (*She takes it from him – he is mesmerised.*) Here's to you. (*Drinks.*)
RIPAFRATTA: (*A gulp.*)
MIRANDOLINA: If one of those buffoons walked in now...
RIPAFRATTA: Oh?
MIRANDOLINA They're always pestering me to have a drink with them.
RIPAFRATTA: I see! (*To SERVANT.*) You're not to breathe a word of this to anyone – is that clear?
SERVANT: Quite clear, sir.
MIRANDOLINA: A toast: *Down with women.* (*Drinks.*)
RIPAFRATTA: Oh yes – I'd never...
MIRANDOLINA: Hmmm?
RIPAFRATTA: (*In her ear.*) I'd never let you change my opinion on that particular subject.
MIRANDOLINA: (*Back in his ear.*) How could I?
RIPAFRATTA: (*To SERVANT.*) You may go.
SERVANT: You want something?

RIPAFRATTA: No.
(*SERVANT doesn't move.*)
Alright – bring me a couple of eggs.
SERVANT: How would you like them done?
RIPAFRATTA: (*In his agitation, can't decide.*) Just bring the damned eggs!
SERVANT: (*To audience.*) Things are hotting up. (*Goes.*)
RIPAFRATTA: You're a wonderful woman.
MIRANDOLINA: Oh, sir – you're making fun of me.
RIPAFRATTA: I want to tell you something.
MIRANDOLINA: Go ahead.
RIPAFRATTA: You're the first woman I've enjoyed talking to – ever. I mean it.
MIRANDOLINA: It's all a question of chemistry, don't you think? Two strangers meet. They hit it off. How does it happen? Search me, but it has. I can honestly say, I've never enjoyed any man's company as much as yours.
RIPAFRATTA: Any more of this and I'll lose my senses.
MIRANDOLINA: Oh, come on, sir – you're an intelligent man. Leave falling in love to fools like the count. The first sign of that, and you won't see me for dust. Of course I'm tempted, but I'm damned if I'm going to give in to it. Besides, how do I know you're not toying with me? Suppose this is just another battle in your campaign against the female sex? Pour some more wine, would you?
RIPAFRATTA: With pleasure. (*Fills her glass.*)
MIRANDOLINA: (*Aside.*) This one's ripe for plucking. (*Aloud.*) Won't you join me?
RIPAFRATTA: Of course. (*Fills her glass. Aside.*) With any luck I'll pass out before things get serious.
MIRANDOLINA: (*Seductive.*) To friendship. (*Clinks his glass.*)
RIPAFRATTA: To friendship.
(*Enter MARQUESS.*)
MARQUESS: Who are you drinking to?
RIPAFRATTA: I'm sorry?
MARQUESS: Never mind. (*To MIRANDOLINA.*) I called – no one came.

MIRANDOLINA: I'll see to it. (*To RIPAFRATTA.*) With your permission. (*Rising.*)
RIPAFRATTA: Wait. (*To MARQUESS.*) Just what do you think you're playing at?
MARQUESS: I do apologise. I had no idea I was interrupting something. So you're her latest convert, are you?
MIRANDOLINA: I was just serving this gentleman, when I got a bit of a turn. He very kindly offered me a glass of burgundy.
MARQUESS: Burgundy, eh?
RIPAFRATTA: That's right.
MARQUESS: It's the genuine article.
RIPAFRATTA: It ought to be, at the price.
MARQUESS: Let me taste it. I know about wine.
RIPAFRATTA: (*Calls.*) Guido!
(*Enter SERVANT with eggs.*)
RIPAFRATTA: Fetch a glass for the marquess here.
MARQUESS: And make it a large one.
SERVANT: I brought your eggs, sir. (*Puts them down on the table.*)
MARQUESS: I loathe eggs.
RIPAFRATTA: No one's asking you to eat them.
MIRANDOLINA: (*To RIPAFRATTA.*) Would it be alright if he tried some of that? (*Indicates pigeon.*)
MARQUESS: It looks wonderful. (*To SERVANT.*) Bring me a plate.
(*SERVANT brings one.*)
And a fork.
(*SERVANT brings one.*)
RIPAFRATTA: For God's sake, just set a place for him. (*SERVANT does so.*)
MIRANDOLINA: I feel a lot better now. I ought to be going.
MARQUESS: I'd like you to stay.
RIPAFRATTA: What do you want with her?
MARQUESS: I'd like you both to try this madeira I've discovered. You've never tasted anything like it.

RIPAFRATTA: (*To MIRANDOLINA.*) You'd better stay, then – to please the marquess.
MIRANDOLINA: I'm sure he can do without me.
MARQUESS: You don't want to try it?
MIRANDOLINA: Some other time, your excellency.
MARQUESS: No. Now.
MIRANDOLINA: Is that an order?
RIPAFRATTA: It is.
MIRANDOLINA: Then I obey. (*Sits.*)
RIPAFRATTA: (*Aside.*) She's putty in my hands.
MARQUESS: What a dish! (*Lifts lid – smells.*) What a smell! (*Tears a piece of pigeon off and tosses it into his mouth.*) What a pigeon!
RIPAFRATTA: What the hell's the matter with him?
MIRANDOLINA: Do you suppose he might be jealous?
RIPAFRATTA: Are you hiding something?
MIRANDOLINA Please! I don't care a fig about him.
RIPAFRATTA: And what about the rest of us?
MIRANDOLINA: I thought we were two of a kind, you and I.
RIPAFRATTA: You're determined to make me pay for that, aren't you?
MIRANDOLINA: Pay for what?
RIPAFRATTA: Oh, come on – you know what I'm talking about.
MARQUESS: Your health! (*He toasts RIPAFRATTA.*)
RIPAFRATTA: (*To MARQUESS.*) Well? What do you think of it?
MARQUESS: Not a patch on my madeira. No offence.
RIPAFRATTA: Oh, really? And where is this famous madeira?
MARQUESS: I've brought it with me. I want us to enjoy it together. (*He produces a half-bottle.*)
RIPAFRATTA: Nothing in excess, eh?
MARQUESS: This is a wine to be savoured. Like nectar. Glasses!
(*The SERVANT brings three small wine glasses.*)
Haven't you got anything smaller? (*Covers bottle with hand.*)

RIPAFRATTA: Fetch the liqueur glasses.
MIRANDOLINA: I'm sure the bouquet will be enough.
MARQUESS: It's certainly quite something. (*Smells bottle.*) Ah!
(*The SERVANT brings the glasses and MARQUESS pours, taking care not to overdo it.*)
(*Tastes.*) Manna from Heaven!
RIPAFRATTA: (*To MIRANDOLINA.*) What's the verdict?
MIRANDOLINA: (*Low voice, to RIPAFRATTA.*) It reminds me of some castor oil I had once.
MARQUESS: Well…?
RIPAFRATTA: It's excellent. Beats the burgundy hands down.
MARQUESS: (*To MIRANDOLINA.*) What about you? Do you like it?
MIRANDOLINA: You want my honest opinion?
MARQUESS: Of course.
MIRANDOLINA: It's revolting. It's quite possibly the worst wine I've ever tasted. I'm afraid pretence isn't my strong suit. Once you start hiding your true feelings, there's no telling where it'll end.
RIPAFRATTA: (*To audience.*) A glance at me? But why?
MARQUESS: Well, if I may say so, it's your loss. Mind you, I can't say I'm surprised, after your response to the handkerchief. (*Drinks a second glass.*)
MIRANDOLINA: (*To RIPAFRATTA.*) Isn't he the limit? (*RIPAFRATTA is about to say something.*) Yes…?
MARQUESS: (*To SERVANT.*) Fetch three clean glasses.
MIRANDOLINA: No, really – I'd better not.
MARQUESS: This isn't for you. (*To SERVANT.*) Go and find Count Albafiorita. Tell him he's welcome to join me in my room for a glass of madeira. And make sure those women hear you.
SERVANT: Right you are, sir. (*Aside.*) No danger of his getting a hangover, at any rate.
RIPAFRATTA: My dear marquess, your generosity knows no bounds.

MARQUESS: (*Indicates MIRANDOLINA.*) I'm madly in love with her, you know.

RIPAFRATTA: Then I'm sorry for you.

MARQUESS: You! What do you know of love?

RIPAFRATTA: Have it your own way.

MARQUESS: I'll have you know, I'm an extremely jealous man. I don't mind her seeing you – but anyone else… (*He makes a throat-cut gesture – RIPAFRATTA repeats it in the interrogative mode – MARQUESS repeats it in the affirmative.*)

RIPAFRATTA: (*Aside.*) This man's beginning to bore me. (*SERVANT returns with bottle.*)

MARQUESS: What did he say?

SERVANT: He said thanks very much, and why don't you try his brandy instead.

MARQUESS: I see! So he's trying to score points over me again, is he? Send it back. (*To MIRANDOLINA.*) You must ask him to leave. I demand that you ask him to leave. I've got a position to keep up, dammit. (*Goes.*)

RIPAFRATTA: The man's insane. And it's pretty clear who's responsible.

MIRANDOLINA: You don't mean…?

RIPAFRATTA: Of course. Who else?

MIRANDOLINA: (*Rising.*) If you're implying that I…that he…that we…

RIPAFRATTA: Wait.

MIRANDOLINA: No, I'm sorry… (*Makes to go.*)

RIPAFRATTA: (*With authority.*) I said: *Wait.*

MIRANDOLINA: (*Freezes.*) What do you want?

RIPAFRATTA: (*Is going to say something, then thinks better of it.*) Nothing. How about a spot more wine?

MIRANDOLINA: Alright, but it'll have to be a quick one.

RIPAFRATTA: Sit down.

MIRANDOLINA: No.

RIPAFRATTA: (*Gentle, handing her a glass.*) Here.

MIRANDOLINA: I'll sing you a song, then I'm off. I learnt this from my nurse:

GOLDONI

> Wine and love, wine and love –
> Don't know which I'm fonder of:
> Through the eyes or through the throat –
> Either pleasure gets my vote!
> I drink to them, and know that you –
> Despite your frowns – are drinking too.

RIPAFRATTA: (*Calls after her.*) Don't rush off... I want to tell you... She's gone. Leaving a hundred devils behind to torment me.

SERVANT: Fruit, sir. Where shall I put it?

RIPAFRATTA: Go to hell! (*SERVANT goes.*)

'I drink to them and know that you –
Despite your frowns are drinking too.'

I see her game. She's trying to destroy me. But she does it so beautifully, the little witch! No – I'm off to Livorno. I don't want to see her again. If I can't get her out of my system now, I never will. I hope to God our paths don't cross again. To hell with women. From now on, I'm going to avoid them completely.

Scene 2

COUNT's room.

COUNT: The marquess is a curious fowl. He's got pedigree, alright, but precious little else. He and his father have squandered the family fortune between them. He's scarcely got a bean to his name. But he insists on acting the grandee.

ORTENSIA: He obviously wants to be generous – he's just got nothing to be generous with.

DEJANIRA: He gives what he can and broadcasts it afterwards.

COUNT: He'd do well in a comedy, don't you think?

ORTENSIA: Wait till the rest of the troupe arrives and we get into the theatre. Then we'll have some fun.

DEJANIRA: We've got some first class mimics.

COUNT: I hope you can do ladies, too.

ORTENSIA: I can. Dejanira's hopeless. She always gives the game away.
DEJANIRA: I love it when people are taken in.
COUNT: You did well to let me in on your little secret. I think I can be of service to you.
ORTENSIA: I think he's offering his protection.
DEJANIRA: Remember our rule: share and share alike.
COUNT: I'll be honest with you: my protection will have certain limits.
ORTENSIA: You mean you're spoken for?
COUNT: I'll tell you this in strict confidence: I'm in love with Mirandolina.
ORTENSIA: A count in love with an innkeeper? That's ridiculous.
DEJANIRA: You could at least have fallen for an actress.
COUNT: Actresses? Now you see them, now you don't. That's not my style.
DEJANIRA: Why not? You get all the fun and none of the boredom. And it's cheaper, too.
COUNT: All the same, I'm afraid I can't oblige, I couldn't possibly offend the love of my life.
DEJANIRA: But what's so special about her?
COUNT: Oh, she's quite a woman.
ORTENSIA: But what about Dejanira? She's got a fabulous complexion.

(*She motions to DEJANIRA to put some rouge on.*)

COUNT: Well, it's hard to define. She has a great soul.
DEJANIRA: What about us? We've got souls.
COUNT: Come on, this isn't fair. I love her – that's all there is to it. And you must learn to get on with her, if we're to be friends.
ORTENSIA: Oh, she's amazing – Venus incarnate.
DEJANIRA: I quite agree: a paragon – intelligent, vivacious…
COUNT: Better. Much better.
ORTENSIA: There's plenty more where that came from.
COUNT: (*Looking off.*) Ah! There goes another stock character.

ORTENSIA: Who do you mean?
COUNT: Ripafratta. He's a misogynist.
DEJANIRA: He must be mad.
ORTENSIA: He was probably unlucky in love.
COUNT: It's worse than that. He's never even been in love. He avoids women like the plague. Even Mirandolina.
ORTENSIA: Poor man. If I could just get my hands on him, he'd change his mind – eventually.
DEJANIRA: That's quite a task. Bags first go.
COUNT: If you could manage that, you wouldn't lose by it, I promise you.
ORTENSIA: Don't worry. We're doing this for the fun of it.
DEJANIRA: Yes. Save the presents for later.
COUNT: Anyway, I doubt if you'll succeed.
ORTENSIA: Thanks!
DEJANIRA: We may not be in the Mirandolina class, but we do know a thing or two.
COUNT: Shall I send for him?
ORTENSIA: If you like
COUNT: (*Calls.*) Giuseppe!
(*The COUNT's SERVANT enters.*)
Tell Ripafratta I want to speak to him.
SERVANT: He's not in his room.
COUNT: I saw him heading for the kitchen. You'll find him there.
SERVANT: Right you are, sir. (*Goes.*)
COUNT: God knows what he's up to in the kitchen. Probably complaining about the food.
DEJANIRA: I was hoping to get a handkerchief or two out of him.
COUNT: Handkerchiefs? I've got handkerchiefs.
DEJANIRA: I'm in dire need.
(*He produces one and offers it to her.*)
COUNT: It's clean.
DEJANIRA: Much obliged.
COUNT: Ah! Here comes Ripafratta. Put on your act again. It'll give you more of a chance. And you'd better hide, if he sees you, he'll just scuttle off.

DEJANIRA: Where's he from?
COUNT: Tuscany.
ORTENSIA: Rich?
COUNT: Stinking.
DEJANIRA: Married?
COUNT: You must be joking.
 (*ORTENSIA and DEJANIRA hide immediately.
 Enter RIPAFRATTA.*)
RIPAFRATTA: You wanted to see me?
COUNT: I hope I haven't disturbed you.
RIPAFRATTA: Just tell me what's up.
COUNT: Two ladies here are dying to meet you.
 (*He signs to the two 'ladies', who advance on RIPAFRATTA, who in turn backs towards the door.*)
RIPAFRATTA: I'm sorry. I don't have time to talk.
ORTENSIA: Is something bothering you?
DEJANIRA: We just wanted a quick word.
RIPAFRATTA: I've got a pressing engagement.
ORTENSIA: It won't take a minute.
RIPAFRATTA: (*Aside.*) Damn this count!
COUNT Ripafratta, where are your manners?
RIPAFRATTA What is it, then?
DEJANIRA: Weelll... (*To ORTENSIA.*) You go first.
ORTENSIA: Weelll...
RIPAFRATTA: Oh, for pity's sake!
COUNT: Perhaps I'd better make a discreet exit.
 (*ORTENSIA and DEJANIRA nod as one.*)
 I'll see you later, then.
RIPAFRATTA: (*Calling after him in alarm.*) Where are you going?!
ORTENSIA: Shall we sit?
RIPAFRATTA: I'd rather stand.
DEJANIRA: Aren't we the rough diamond.
RIPAFRATTA: Would you mind telling me what this is about?
ORTENSIA: We want something from you.
 (*RIPAFRATTA tries to speak – nothing comes out.*)
DEJANIRA: Your protection.

RIPAFRATTA: (*Choking noise – finally, but only just.*) What for?
ORTENSIA: Our husbands have abandoned us.
RIPAFRATTA: They have? Why?
DEJANIRA: Do we tell him?
ORTENSIA: I'm not sure. He's not exactly a sympathetic audience.
RIPAFRATTA: Right – I'll be off, then.
ORTENSIA: Hey!
DEJANIRA: That's no way for a gentleman to behave.
RIPAFRATTA: Sorry – I like to be left alone, you see. Two ladies, abandoned by their husbands – it's just not my bag. I lead a quiet life. I'm not your man. Really.
ORTENSIA: Alright – we'll tell you the whole story.
DEJANIRA: We're not ladies.
RIPAFRATTA: Eh?
ORTENSIA: She means we're women.
DEJANIRA: The count wanted to play a trick on you.
RIPAFRATTA: Fine. Well, if that's all… (*Going.*)
ORTENSIA: Wait!
RIPAFRATTA: What is it now?
DEJANIRA: Stay and talk for a bit.
RIPAFRATTA: Look, for the last time – I'm busy.
ORTENSIA: It's alright – we know about your little problem.
RIPAFRATTA: Problem? What problem?
DEJANIRA Your thing about women.
RIPAFRATTA Then I'm the last person you should want to be with. (*Makes to go.*)
ORTENSIA: But listen – how can I put this – we're not the troublesome kind. Here today, gone tomorrow – and as much pleasure as possible in between – that's our motto.
RIPAFRATTA: (*Revelation.*) Ah! You're actresses!
ORTENSIA: Got it in one.
RIPAFRATTA: (*Huge relief.*) Why didn't you tell me that in the first place? I simply adore the theatre.
ORTENSIA: You do?
RIPAFRATTA: Of course. You act on stage and off – isn't that right?

ORTENSIA: I don't know what you're talking about.
RIPAFRATTA: Of course you do.
DEJANIRA: Now, look here...
RIPAFRATTA: Hm? (*They are stumped.*) Tell me – what are your favourite routines?
ORTENSIA: Are you implying...?
RIPAFRATTA: How do you go about it? Fleecing your lovers, I mean.
DEJANIRA: How dare you!
ORTENSIA: Oh, you darling man!
(*She makes to embrace him, watched in stupefaction by DEJANIRA.*)
RIPAFRATTA: Steady!
(*Cautiously, he takes her on his knee, positioning her hands with great precision on appropriate parts of his anatomy.*)
ORTENSIA: You know, I think I prefer him to the count.
(*DEJANIRA, capitulating now, takes the other knee.*)
RIPAFRATTA: Yes, and God only knows what you've been getting up to with him! You saucy creatures! (*He forces ORTENSIA into a kiss.*) Hang on – have I smudged your make-up? What's got into her? (*He turns his attention to DEJANIRA, dislodging her wig in the process.*) Oops! Sorry!
DEJANIRA: Well, really!
(*RIPAFRATTA's SERVANT enters, interrupting the proceedings. The girls scurry off.*)
SERVANT: Sir...
RIPAFRATTA: What is it?
SERVANT: The marquess wants to speak to you.
RIPAFRATTA: What about? If he wants to borrow money, he'll have to go elsewhere. And tell Fabrizio I want my bill – as soon as possible.
SERVANT: Right you are, sir. (*Goes.*)
RIPAFRATTA: I think I handled those actresses rather well. But Mirandolina's still a problem. I'm definitely leaving tomorrow. (*Thinks.*) But should I wait that long? Tonight it is, then. What a predicament. I don't want to leave – I can't risk staying. Women! Even when they're nice to you, it's a disaster.

(*FABRIZIO enters.*)
FABRIZIO: Did you really want the bill, sir?
RIPAFRATTA: Yes. Is it ready?
FABRIZIO: The landlady's seeing to it.
RIPAFRATTA: She does the bills herself?
FABRIZIO: Always has done. Even when her father was alive. She's a genius at accounts.
RIPAFRATTA: (*Aside.*) What an amazing creature!
FABRIZIO: This is a bit sudden, isn't it?
RIPAFRATTA: Something's cropped up that can't wait.
FABRIZIO: I hope you won't forget us servants.
RIPAFRATTA: Just bring me the bill and leave the rest to me.
FABRIZIO: You want it here?
RIPAFRATTA: That's right. I'm not going to my room just yet.
FABRIZIO: Very wise, sir, if I may say so. I saw that wretched marquess snooping about just now. God, he's a pain! The way he pesters Mirandolina. Well, he'd better think again, because she's going to be my wife.
RIPAFRATTA: Just bring the bill, would you?
FABRIZIO: Coming right up. (*Goes.*)
RIPAFRATTA: Is there anyone round here who isn't in love with that woman? Oh, God! Here she comes now. (*Mutters, prayer-fashion.*) Keep calm. Two hours to go.
MIRANDOLINA: (*Tentative, hovering in the doorway.*) Sir... You wanted your bill...
RIPAFRATTA: That's right. Come in, Mirandolina.
MIRANDOLINA: (*Coolly.*) I've drawn it up.
(*Offers bill, wiping eyes with apron.*)
RIPAFRATTA: What's this? Tears?
MIRANDOLINA: It's nothing. I got some smoke in my eyes.
RIPAFRATTA: You did? Allow me... (*Snaps out of it.*) Right! Let's see the damage. (*Reads bill.*) Twenty florins! It must be more than that.
MIRANDOLINA: I don't see why.
RIPAFRATTA: What about lunch – the pigeon...?

MIRANDOLINA: Compliments of the house.
RIPAFRATTA: But really…
MIRANDOLINA: Not another word. I did it out of…
(*Covers face, eyes streaming now.*)
RIPAFRATTA: How did it happen?
MIRANDOLINA: The oven's been playing up.
RIPAFRATTA: Then it's all my fault. You were cooking for me.
MIRANDOLINA: It's a small price to pay.
RIPAFRATTA: (*Aside.*) I have to get out of here. Now. (*Aloud.*) Take this. (*Hands her a bulging purse.*) And think of me sometimes.
(*MIRANDOLINA says nothing, but collapses in a chair.*)
Mirandolina! Oh my God! Mirandolina? She's in love with me! It's a bit sudden, but why not? If it happened to me it could happen to anyone. Mirandolina – my darling… (*Aside.*) Did I really say that? (*Aloud.*) My God, but you're beautiful! I need something to revive her. (*Calls.*) Hello there! (*Silence.*) I'll go myself. My poor darling! Don't move. I'll be right back. (*Goes.*)
MIRANDOLINA: Got him that time! Women have all sorts of methods for conquering men, but when in doubt – pass out. He's coming back!
(*She 'passes out' again.*)
RIPAFRATTA: (*Re-entering with glass of water.*) Still out. She's in love with me alright. This should do the trick. (*He splashes her with water – she stirs.*) I'm here, my dearest. I won't desert you. Not now.
(*Enter SERVANT.*)
SERVANT: Your hat and sword, sir.
RIPAFRATTA: Get out!
SERVANT: And the bags…
RIPAFRATTA: I said: get out!
SERVANT: (*Seeing MIRANDOLINA.*) She's fainted.
RIPAFRATTA: If you don't go now, I'll crack your skull. (*Threatens SERVANT with glass. SERVANT goes.*)
Still not coming round. And her forehead's all sweaty. Mirandolina! Open your eyes. There's nothing to fear. Talk to me. Tell me everything.

(*Enter MARQUESS and COUNT.*)
MARQUESS: Ripafratta.
COUNT: Hello there
RIPAFRATTA: (*Aside.*) Damn them!
MARQUESS: Mirandolina!
MIRANDOLINA: (*Rises.*) Where am I?
MARQUESS: You all saw that. I revived her.
COUNT: (*To RIPAFRATTA.*) Well – aren't you the lucky one.
MARQUESS: So much for the misogynist.
RIPAFRATTA: Are you implying…?
COUNT: Admit it: you're hooked.
RIPAFRATTA: Go to hell, all of you.
 (*He throws a glass of water on the floor – it breaks at their feet – then makes a furious exit.*)
COUNT: He's insane! (*Goes.*)
MARQUESS: He hasn't heard the last of this. (*Goes.*)
MIRANDOLINA: I'm a genius! The man's completely besotted. All I have to do to complete my triumph is make it known – to the eternal shame of presumptuous men, and the glory of womankind.

End of Act Two.

ACT THREE

Scene 1

MIRANDOLINA's room. Small table. Pile of laundry. MIRANDOLINA discovered, looking for the iron.

MIRANDOLINA: Fabrizio!
FABRIZIO: (*Enters.*) What is it?
MIRANDOLINA: Is the iron ready yet?
FABRIZIO: I'll just get it. (*Going.*)
MIRANDOLINA: If it's any trouble...
FABRIZIO: It's no trouble. You feed me, I slave my guts out for you. It's a fair bargain. (*Going.*)
MIRANDOLINA: Wait. No one's asking you to slave your guts out. I thought you liked working for me. For my part I...well, enough said.
FABRIZIO: I'd do anything for you. I'd carry a bucket on each ear. Not that it'd get me anywhere.
MIRANDOLINA: You're saying I'm ungrateful?
FABRIZIO: No. After all, why should you bother about a mere menial, when the place is crawling with counts?
MIRANDOLINA: You're being ridiculous. I can assure you that... (*Checks herself.*) Just fetch the iron would you?
FABRIZIO: But what if I saw you with my own eyes?
MIRANDOLINA: I'm not discussing this. Now, are you going to fetch that iron, or shall I go myself?
FABRIZIO: One iron, coming right up.
(*He stomps out.*)
MIRANDOLINA: These men, they're all the same. The nicer you are to them, the tetchier they get.
FABRIZIO: (*Coming back, softening.*) What was that?
MIRANDOLINA: Nothing.
FABRIZIO: I thought you said something.
MIRANDOLINA: Not me.
(*He does an ironing gesture. She reciprocates. He goes, passing RIPAFRATTA's SERVANT on the way. MIRANDOLINA watches him, shaking her head.*)

SERVANT: Miss Mirandolina...
MIRANDOLINA: What can I do for you?
SERVANT: My master sent me. He wanted to know how you were.
MIRANDOLINA: I'm fine, thanks.
SERVANT: He wanted you to try this. It's peach brandy. The best. (*Produces gold flask and hands it to her.*)
MIRANDOLINA: I could have done with this when I fainted. It would have brought me round in no time.
SERVANT: He didn't have it then.
MIRANDOLINA: Oh?
SERVANT: I shouldn't tell you this, but I've just got back from the goldsmiths. It set him back quite a bit.
MIRANDOLINA: Well I'm afraid it's a bit late now. (*Handing it back.*)
SERVANT: Oh, no – the flask's yours.
MIRANDOLINA: Mine?
SERVANT: That's right. He bought it for you.
MIRANDOLINA: He did?
SERVANT: That's right.
MIRANDOLINA: Thank him, but tell him I couldn't possibly accept it.
SERVANT: I can't do that.
MIRANDOLINA: I'm afraid you're going to have to.
SERVANT: But he'll be very upset.
MIRANDOLINA: Too bad. Here. (*Offers it.*)
SERVANT: If you must. (*Takes it. Aside.*) What a woman! This cost thirty florins. (*Goes.*)
MIRANDOLINA: I knew I'd hooked him, but this is ridiculous. Still, I'm not taking anything from him. I want him to love women – not to go around saying how mercenary they are.
(*FABRIZIO enters with iron.*)
FABRIZIO: Here it is.
MIRANDOLINA: Is it good and hot?
FABRIZIO: It certainly is. Not as hot as me, though.
MIRANDOLINA: Oh? What's up now?
FABRIZIO: Ripafratta's been sending you presents. His servant told me.

MIRANDOLINA: He sent me a gold flask. I returned it.
FABRIZIO: You did what!
MIRANDOLINA: That's right. Ask the servant if you don't believe me.
FABRIZIO: But why?
MIRANDOLINA: Because, Fabrizio, I don't intend to... No, I don't see why I should explain to you.
FABRIZIO: Mirandolina, for pity's sake.
MIRANDOLINA: Be off with you. I've got ironing to do.
FABRIZIO: I'm not stopping you, am I?
MIRANDOLINA: I'm going to need another of these. (*Meaning iron.*) Get one ready, would you?
FABRIZIO: But listen...
MIRANDOLINA: If you say another word...
FABRIZIO: Alright, alright – peace. (*Goes.*)
MIRANDOLINA: I handled that very well. He's bound to be pleased that I refused the flask. There's not a lot you can teach me about men – or anything else, for that matter. I'm a credit to my sex.
(*RIPAFRATTA enters.*)
RIPAFRATTA: (*Aside, rear stage.*) There she is now. I didn't want to come. This is the devil's work.
MIRANDOLINA: (*Aside, spotting RIPAFRATTA in corner of eye, and starting to iron.*) It's him!
RIPAFRATTA: Mirandolina...
MIRANDOLINA: What can I do for you?
RIPAFRATTA: How are you feeling?
MIRANDOLINA: Never better. (*Still ironing – not looking at him.*)
RIPAFRATTA: I've got a small bone to pick with you.
MIRANDOLINA: How come?
RIPAFRATTA: The flask. You sent it back.
MIRANDOLINA: What did you want me to do with it?
RIPAFRATTA: Keep it for emergencies, of course.
MIRANDOLINA: But I'm not given to fainting. Today was a first.
RIPAFRATTA: So it was all my fault.
MIRANDOLINA: I suppose it must have been.

RIPAFRATTA: Oh, God! Really?

MIRANDOLINA: (*Ironing like mad now.*) You made me drink that wine. It didn't agree with me.

RIPAFRATTA: The burgundy? It's not possible.

MIRANDOLINA: I'm afraid it is. I shan't be coming to your room again. The iron's getting cold. (*Calls.*) Fabrizio! Bring me the other iron, would you?

RIPAFRATTA: Please – for my sake – take the flask. (*Producing it.*)

MIRANDOLINA: I'm sorry. I can't accept presents.

RIPAFRATTA: You accepted the count's...

MIRANDOLINA: He forced me to. And anyway, what do you care?

RIPAFRATTA: I've changed.

MIRANDOLINA: Since when?

RIPAFRATTA: Since I met you, of course.

MIRANDOLINA: (*Laughs.*) Oh, come on.

RIPAFRATTA: What's so funny?

MIRANDOLINA: Well, you're having me on, aren't you?

RIPAFRATTA: Having you on! Take it. NOW. (*He foists the flask on to her.*)

MIRANDOLINA: (*Still ironing.*) Sorry.

RIPAFRATTA: (*Pathetic menace.*) If you don't take it, I shan't be answerable for my actions.

MIRANDOLINA: (*Calls.*) Fabrizio! Where's that iron?

RIPAFRATTA: (*Desperate.*) Please...

MIRANDOLINA: Oh, what the hell? (*She takes the flask and tosses it into the laundry basket.*)

RIPAFRATTA: Mirandolina! How could you?

MIRANDOLINA: Fabrizio!

FABRIZIO: Alright, alri– (*Sees RIPAFRATTA; is instantly suspicious.*)

MIRANDOLINA: Is it hot enough?

FABRIZIO: Should be.

MIRANDOLINA: What's the matter? You seem upset.

FABRIZIO: Upset? Me?

MIRANDOLINA: Yes. What is it?

FABRIZIO: You'd better give me the other iron. I'll heat it up again.

MIRANDOLINA: No, wait a minute – I'm worried about you.
RIPAFRATTA: Just give him the iron!
MIRANDOLINA: (*To RIPAFRATTA.*) You stay out of this.
RIPAFRATTA: (*Aside.*) I give in.
MIRANDOLINA: Here you are, dear. (*Passes first iron to FABRIZIO, all concern.*) Heat it up, if you insist – but in your own good time, do you hear?
FABRIZIO: (*Gobsmacked.*) I – er –
MIRANDOLINA: Off you go now.
FABRIZIO: What the hell's happening here? (*Goes.*)
RIPAFRATTA: You're very polite to your menials.
MIRANDOLINA: I'm sorry?
RIPAFRATTA: Oh, come on – you're mad about him.
MIRANDOLINA: Mad about a servant? You certainly know what to say to a girl. Let me tell you, I set my sights a little higher than that. (*Resumes ironing.*) When the time comes...
RIPAFRATTA: (*Softening again.*) You'll marry a king.
MIRANDOLINA: Clubs or diamonds?
RIPAFRATTA: Can't we talk seriously for a change?
MIRANDOLINA: Go ahead. I'm all ears.
RIPAFRATTA: Can't you stop ironing for one minute?
MIRANDOLINA: (*About to speak, breaks off; then.*) This has to be ready for tomorrow morning.
RIPAFRATTA: It's me or the ironing. Take your pick. (*MIRANDOLINA looks up, as though considering it; then resumes ironing.*) Listen...
MIRANDOLINA: No. You listen. Men come, men go – a good pillow case is for life.
RIPAFRATTA: But I'm not going anywhere. You can do what you like with me.
MIRANDOLINA: I wouldn't know where to start.
RIPAFRATTA: Would you mind telling me why you're tormenting me like this? I love you. I'd love any woman like you, but I doubt if two exist. Couldn't you at least take pity on me?

MIRANDOLINA: I've never heard such nonsense.
(*But she is clearly agitated, and drops the handkerchief she has been ironing.*)
RIPAFRATTA: (*Picks up handkerchief; gives it her.*) Believe me.
MIRANDOLINA: Look, I'm not worth it.
RIPAFRATTA: Oh, but you are. I'd go to hell and back for you.
(*MIRANDOLINA starts to laugh again.*)
I can't take much more of this. (*He collapses in a chair.*)
MIRANDOLINA: Are you alright?
RIPAFRATTA: I feel a bit faint.
MIRANDOLINA: You'd better have some brandy. (*Tosses him the flask.*)
RIPAFRATTA: God, you're a heartless woman! For the last time, I'm on fire with love for you! I – I –
(*He lunges at her, misses, burns his hand on the iron, which she is still holding, and screams in pain.*)
MIRANDOLINA: I'm sorry. That wasn't deliberate. I'll put something on it for you. (*Calls.*) Fabri–
RIPAFRATTA: (*Clapping a hand over her mouth in mid-word.*) If that boy sets foot in here again, I'll crack his skull for him. Call someone else.
MIRANDOLINA: I'll call who I damn well like.
(*He is advancing towards her again.*)
Don't even think about it! (*Raising the iron in self-defence.*)
RIPAFRATTA: Don't you understand? I'm not responsible for my actions any more.
MIRANDOLINA: Do you have to follow me around like a dog?
RIPAFRATTA: Yes, perhaps I do. All this is so new to me, you see.
MIRANDOLINA: That's no excuse for bullying. (*Moving away from him.*)
RIPAFRATTA: I didn't mean to. (*Following her.*)
MIRANDOLINA: (*Losing patience at last.*) I'm not hearing this. A few hours ago you couldn't bear to look at a woman. Now you're after – just what are you after?

RIPAFRATTA: Love, compassion, pity...
MIRANDOLINA: It's a joke. It's not possible. I refuse to believe it. (*Aside.*) Let him whine to his heart's content. He'll just have to learn to hate women again. (*Goes.*)
RIPAFRATTA: I curse the day I met her. I'm in the trap now, and there's nothing I can do about it.
(*Enter MARQUESS.*)
MARQUESS: Sir – you have insulted me.
RIPAFRATTA: I'm sorry. It was an accident.
MARQUESS: Accident!
RIPAFRATTA: The glass didn't hit you.
MARQUESS: True. But I got some water on my waistcoat.
RIPAFRATTA: You did? I'm sorry.
MARQUESS: That's not good enough.
RIPAFRATTA: Look, couldn't we just...
MARQUESS: I demand satisfaction.
RIPAFRATTA: Alright, then! I'm not about to be intimidated by the likes of you.
MARQUESS: (*Suddenly very meek.*) It's this stain, you see. I don't think it's going to come out...
RIPAFRATTA: (*Scornful.*) I've apologised. What more can a gentleman do?
MARQUESS: If it really was an accident, perhaps we could leave it there.
RIPAFRATTA: It's your choice. If you want satisfaction, I'm ready for you.
MARQUESS: We'll say no more about it, then.
RIPAFRATTA: Coward!
MARQUESS: This is ridiculous: I've calmed down, and now you're working yourself up.
RIPAFRATTA: That's right. I'm in the mood.
MARQUESS: I sympathise. I know what you're going through.
RIPAFRATTA: Is it any of your business?
MARQUESS: The woman-hater finally succumbed, eh?
RIPAFRATTA: Who? Me?
MIRANDOLINA: That's right. You're in love.
RIPAFRATTA: To hell with you.

MARQUESS: It's no use hiding it.
RIPAFRATTA: Leave me alone, or by Heaven you'll live to regret it. (*Goes.*)
MARQUESS: (*Alone.*) He's in love, he's ashamed of it, and he doesn't want anyone to know. Or perhaps he's hiding it because he's afraid of what I'll do to him. That's it. But what about this damned stain? Some fuller's earth should do it. (*He starts to look around for some – on the table, in the basket.*) What's this? A flask? Nice! Is it gold or gilt? Must be gilt, or they wouldn't have left it lying around. (*He unscrews the cap, sniffs, tastes.*) Melissa spirits. I wonder...
(*He puts some on a handkerchief and starts to work at the stain with it. Enter DEJANIRA.*)
DEJANIRA: My dear marquess, what are you doing here all by yourself? Is she still playing hard to get?
MARQUESS: (*Awkward.*) I just thought I'd see how she was getting on.
DEJANIRA: What were you up to when I came in?
MARQUESS: Trying to get rid of this stain. I'm a great stickler for cleanliness.
DEJANIRA: What with?
MARQUESS: Melissa spirits.
DEJANIRA: That'll just make it worse.
MARQUESS: What would you suggest?
DEJANIRA: I've a little trick of my own.
MARQUESS: Show me.
DEJANIRA: With pleasure. Give me a gold coin, and I'll get it out for you. No one'll ever know it was there.
MARQUESS: What sort of gold coin?
DEJANIRA: A crown should do it.
MARQUESS: A crown!
DEJANIRA: Does that seem a lot?
MARQUESS: I think I'll stick to the spirits.
DEJANIRA: What are they like?
MARQUESS: Superb. Smell that. (*Hands flask.*)
DEJANIRA: Mmm. Just like my mother makes. Nice flask, too. Gold, is it?

MARQUESS: That's right. (*Aside.*) She can't tell gold from gilt.
DEJANIRA: Is it yours?
MARQUESS: It's yours, if you want it.
DEJANIRA: That's uncommonly generous of you. (*Pockets it.*)
MARQUESS: Oh, come on.
DEJANIRA: You're not giving it me?
MARQUESS: On the contrary: you deserve something better. It's worthless.
DEJANIRA: But I'm quite happy with it.
MARQUESS: I'll be honest with you: it's not gold – it's gilt.
DEJANIRA: I don't mind. You gave it me – that's what counts.
MARQUESS: By all means, take it. (*Aside.*) Blast! Now I'll have to pay for it. Oh, well – it can't have cost much.
DEJANIRA: Really, I don't know what to say.
MARQUESS: Nonsense. I only wish it were gold.
DEJANIRA: I must say, it's a very good imitation.
MARQUESS: Not a bad effort, no. But the connoisseur can always tell.
DEJANIRA: Are you sure? It's pretty heavy.
MARQUESS: No, no – gilt – definitely gilt.
DEJANIRA: I must show this to Ortensia.
MARQUESS: The baroness?
DEJANIRA: That's right, the baroness.
(*She goes, laughing – and passing RIPAFRATTA's SERVANT.*)
SERVANT: (*Searching under table.*) Now, where's it got to?
MARQUESS: What are you looking for?
SERVANT: A flask. Mirandolina wants it. She said she left it here.
MARQUESS: Not a gilt flask, by any chance?
SERVANT: No, no – gold.
MARQUESS: Gold?
SERVANT: That's right. My master bought it for her. Cost him twelve crowns.
MARQUESS: Twelve crowns! And she just left it lying around?

SERVANT: That's what she said. Doesn't seem to be here, though. You haven't seen it have you, sir?
MARQUESS: Me! No.
SERVANT: Well, I give in. It's her fault. She should have put it in her pocket. (*Goes.*)
MARQUESS: Oh, my God! What have I done? If I ask for it back, the countess'll think I'm a fool. If I keep quiet, and Mirandolina finds out about it, my dignity will be undermined. I have my standing to think about. I'll have to pay her for it. But I'm flat broke!
COUNT: (*Entering.*) Well, isn't this amazing news.
MARQUESS: Eh?
COUNT: Ripafratta – the arch misogynist – is in love with Mirandolina.
MARQUESS: All credit to him for recognising a remarkable woman when he saw one. On the other hand, he knows I couldn't possibly tolerate such an unworthy rival. He's in a terrible dilemma.
COUNT: What if she wants him?
MARQUESS: Impossible. She'd never do that to me. She knows my worth, and what I've done for her.
COUNT: I've done a damn sight more than you. But it's been to no avail. Mirandolina's encouraging him. She's been more attentive to him than she ever was to us. You know what women are like: pursue them and they run a mile – ignore them and they're all over you.
MARQUESS: You mean… No – I refuse to credit it.
COUNT: Why not?
MARQUESS: You're seriously comparing that fellow with me?
COUNT: You saw her sitting at the table with him. When did she ever sit with us? Gave him a special laundry service – served him supper herself – she treats him like a husband, and she doesn't care who knows it. Fabrizio's mad with jealousy. And what about that fainting fit? It may have been an act, but it was still clear proof of love.
MARQUESS: My God! You're right! He ate like a prince – I got yesterday's spag bol. Not to mention a minestrone

you could stand your spoon up in. It's a flout to my standing.

COUNT: What about me? I've spent a small fortune on that woman.

MARQUESS: Not forgetting my handkerchief.

COUNT: I gather he's been giving her presents.

MARQUESS: Such as?

COUNT: A gold flask.

MARQUESS: A flask? How do you know?

COUNT: His servant told mine. Oh, yes – that Mirandolina's an ungrateful bitch. For my part, I wash my hands of her. I'm leaving this flea-pit immediately.

MARQUESS: Good idea. Off you go, then.

COUNT: What about you? A marquess. A man of distinction. You're not thinking of staying?

MARQUESS: Where would I go?

COUNT: I'll find you a bed somewhere.

MARQUESS: What do you mean by a bed?

COUNT: One of my peasants'll put you up.

MARQUESS: You're a real friend. I'm touched.

COUNT: I know. Now let's be off. And good riddance to an ignorant slut.

MARQUESS: Well said. Come on, then. (*Aside.*) But what about the flask? I'm an aristocrat – I'm incapable of doing wrong.

COUNT: Let's go – before you change your mind. And in future, if I can help in any way…

MARQUESS: Funny you should say that. As a matter of fact, I am a bit short just now. My bailiff's not pulling his weight.

COUNT: How much do you need?

MARQUESS: Twelve crowns.

COUNT: Twelve crowns!

MARQUESS: I owe it to Mirandolina. I simply have to pay her.

COUNT: Alright then, here you are. (*Takes purse; counts them out.*)

MARQUESS: You couldn't possibly make it thirteen? I owe Ripafratta one.

GOLDONI

COUNT: Twelve – thirteen – what's the difference? Here.
 Tosses him the extra crown.
MARQUESS: I'll pay you back as soon as I can.
COUNT: I won't hold my breath. Seriously, though – I'd
 spend a lot more than that to get my own back on her.
MARQUESS: What do you mean?
COUNT: I'm emptying the inn. The two actresses are
 leaving as well.
MARQUESS: What actresses?
COUNT: Ortensia and Dejanira.
MARQUESS: I thought they were ladies.
COUNT: Then you were misinformed.
MARQUESS: You mean, I gave…
COUNT: Hm?
MARQUESS: Nothing. Where are they staying?
COUNT: At a place near the theatre. Hang on, though –
 why do you…?
 (*But MARQUESS has vanished.*)
 Three down, one to go. I've got something rather
 different in mind for Ripafratta.

Scene 2

A room with three doors.

MIRANDOLINA discovered.

MIRANDOLINA: What a mess! If Ripafratta shows up I'm
 in big trouble. He's in a foul mood. (*She closes the door
 she's come through, after looking out anxiously for any sign of
 RIPAFRATTA.*) I'm starting to regret my little scheme.
 Oh, it was fun, getting him to chase after me like that –
 but things are out of control now. My reputation's at risk
 – possibly even my life. I've got to face the fact that I'm
 on my own. There's no one here with the guts to defend
 me. Except possibly Fabrizio. But he's only a boy. I
 could always promise to marry him, but I doubt if he'd
 believe me. (*Thinks.*) Perhaps I should marry him! At
 least I'd be able to protect my interests – and keep my
 freedom.

(*RIPAFRATTA bangs furiously on the door.*)
MIRANDOLINA: There's someone at the door.
RIPAFRATTA: Open up!
MIRANDOLINA: He must be joking. (*Aloud.*) What is it?
RIPAFRATTA: Open this door, I say!
MIRANDOLINA: Would you mind waiting in your room. I'll be right there.
RIPAFRATTA: Why won't you open it?
MIRANDOLINA: I'm dealing with some guests.
RIPAFRATTA: Alright. (*Menacing.*) But you'd better be quick about it.
MIRANDOLINA: It looks bad. (*She peers through the keyhole.*) All clear. Well, I'm damned if I'm going. (*Calls at another door.*) Fabrizio!
(*FABRIZIO enters.*)
FABRIZIO: You called?
MIRANDOLINA: Look, there's something I've got to tell you…
FABRIZIO: Shoot.
MIRANDOLINA: You know Ripafratta's been after me?
FABRIZIO: I did spot that.
MIRANDOLINA: The man's out of control. He's said things – well, I blush to think of them.
FABRIZIO: I'm not surprised – a young, single woman, with no parents – nobody at all, in fact. If you'd been married, none of this would have happened.
MIRANDOLINA: You're right. As a matter of fact, I thought I might marry.
FABRIZIO: And you remember what your father said?
MIRANDOLINA: Of course I do.
(*RIPAFRATTA bangs on the door again.*)
FABRIZIO: (*Calls.*) Who is it?
RIPAFRATTA: Open up!
FABRIZIO: What do you want? (*About to open the door.*)
MIRANDOLINA: Wait till I've gone. (*Goes.*)
FABRIZIO: (*To her as she goes.*) Don't worry – I'll defend you.
RIPAFRATTA: What's going on in there?

FABRIZIO: What kind of behaviour do you call this – in a respectable establishment?
(*Sounds of door being forced.*)
Christ! He's going to break it down. (*Calls.*) Help! Somebody! Quick!
(*MARQUESS and COUNT enter, middle door.*)
COUNT: What's wrong?
FABRIZIO: (*Low voice.*) It's Ripafratta – he's trying to force his way in.
RIPAFRATTA: This is your last chance!
MARQUESS: He's crazy. Let's get out of here.
COUNT: Open the door. I need to talk to him.
FABRIZIO: Are you sure?
COUNT: Perfectly. We can handle him.
(*FABRIZIO opens the door. RIPAFRATTA bursts in.*)
RIPAFRATTA: (*Raging.*) Where is she?
FABRIZIO: Who were you wanting?
RIPAFRATTA: Who do you think?
FABRIZIO: I've no idea.
MARQUESS: (*Aside.*) Thank God for that. It's her he's after.
RIPAFRATTA: I'll find that woman if it's the last thing I do.
(*As he rampages about, he stumbles on MARQUESS and COUNT.*)
COUNT: (*To RIPAFRATTA.*) What seems to be the trouble?
MARQUESS: (*To RIPAFRATTA.*) Haven't we always been friends?
FABRIZIO: (*To RIPAFRATTA.*) What do you want with Mirandolina?
RIPAFRATTA: I don't owe you an explanation. When I give an order I expect it to be obeyed. I'm the one who pays the bill.
FABRIZIO: You pay for bed and board and that's all.
RIPAFRATTA: I'll be the judge of that.
FABRIZIO: You told her to come to your room.
RIPAFRATTA: What if I did? Do you want to argue about it?
FABRIZIO: This is outrageous!

MARQUESS: (*To FABRIZIO.*) Careful…
COUNT: (*To FABRIZIO.*) You'd better go.
RIPAFRATTA: That's right: get out.
FABRIZIO: (*To RIPAFRATTA.*) Now, look here you…
MARQUESS / COUNT: (*To FABRIZIO.*) Just GO!
FABRIZIO: (*Aside.*) I think they might have a point. (*Goes.*)
RIPAFRATTA: That woman's kept me waiting long enough.
MARQUESS: (*To COUNT.*) What's he talking about?
COUNT: (*To MARQUESS.*) Oh, for God's sake.
RIPAFRATTA: She seems very thick with Fabrizio. Is there something between them?
COUNT: (*Aside.*) Time for my revenge. (*To RIPAFRATTA.*) It seems you were a little hasty to mock other people's afflictions.
RIPAFRATTA: What are you talking about?
COUNT I know why you're in this mood.
RIPAFRATTA: (*To MARQUESS.*) Do you know what he's talking about?
MARQUESS: Who? Me? Haven't a clue.
COUNT: (*To RIPAFRATTA.*) That 'woman-hating' business – it was a front. You were after Mirandolina all along. Poaching on my estate. Look me in the eye and give me a straight answer: are you at all ashamed of your conduct?
RIPAFRATTA: I'm not listening to any more of these lies.
COUNT Lies!
RIPAFRATTA: Alright: what grounds have you for suggesting…?
COUNT: You're the liar – not me.
(*Meanwhile, MARQUESS has been stealing away on tiptoe; RIPAFRATTA shoots out an arm and hauls him back.*)
RIPAFRATTA: Where do you think you're going?
MARQUESS: Nowhere…
COUNT: (*To RIPAFRATTA.*) I demand satisfaction.
RIPAFRATTA: Happy to oblige. (*To MARQUESS.*) Give me your sword.
MARQUESS: Now come on you two – calm down. (*To COUNT.*) What is it to you if he loves Mirandolina?

RIPAFRATTA: Love her? Who says I love her?
MARQUESS: Don't look at me.
RIPAFRATTA: Then who did?
COUNT: Me. I'm saying it.
RIPAFRATTA: (*To MARQUESS.*) Sword…
MARQUESS: Look…
COUNT: Whose side are you on?
MARQUESS: No one's – that is, everyone's.
RIPAFRATTA: Oh, to hell with it.
(*He tugs at MARQUESS's sword, which comes away, scabbard and all.*)
MARQUESS: You must treat me with respect.
RIPAFRATTA: You want satisfaction too?
MARQUESS: I never said that.
(*Meanwhile, COUNT is limbering up – practising positions.*)
COUNT: Ready?
RIPAFRATTA: Ready. (*Tries to draw, but can't.*)
MARQUESS: There's a knack to it.
COUNT: I'm waiting…
RIPAFRATTA: Got it. (*He draws the sword, or rather, the half of it that is left.*) I'll fetch another one. (*Makes to go.*)
COUNT: Not so fast.
RIPAFRATTA: You're expecting me to fight with this?
MARQUESS: It's a good blade – what's left of it.
RIPAFRATTA: Alright, then…
(*He rushes at COUNT, who retreats.
MIRANDOLINA enters.*)
MIRANDOLINA: Put up your swords!
RIPAFRATTA: Ah! There she is.
MIRANDOLINA: A duel – why?
MARQUESS: Why do you think: love.
RIPAFRATTA: (*Indignant.*) Love? Who said anything about love?
MIRANDOLINA: (*To COUNT.*) He's not after me, if that's what you're thinking.
COUNT: Yes he is. And what's more, it's mutual.
MARQUESS: That's right – we've got eyes in our heads.
RIPAFRATTA: (*Menacing.*) Not for long.

MIRANDOLINA: If he's in love with me, why should he deny it? Believe me, I tried, but he's got a heart of stone Isn't that right? (*This to RIPAFRATTA.*) He makes John Knox look like Casanova at a carnival.

RIPAFRATTA: (*Caught.*) Weell...

COUNT: He doesn't sound convinced.

MARQUESS: Who's John Knox?

MIRANDOLINA: (*Continuing.*) You see, he understands women perfectly. Our wiles are like an open book to him. We can talk and cry and faint till we're blue in the face. He won't take a blind bit of notice.

RIPAFRATTA: (*Chuffed.*) Yes, well – (*Double take.*) – wait a minute – did you say: faint?

MIRANDOLINA: Oh, come on – you can't have fallen for that old one?

RIPAFRATTA: This is scandalous!

MIRANDOLINA: Don't get worked up again.

MARQUESS: Again?

MIRANDOLINA: (*To RIPAFRATTA.*) If you're not careful, they'll think you really are in love.

COUNT: Of course he damn well is.

MARQUESS: You can see it in his eyes.

RIPAFRATTA: (*With a telling glance at MIRANDOLINA.*) That's smoke.

MIRANDOLINA: (*Unruffled, to COUNT / MARQUESS.*) You've got it all wrong. What's more, I can prove it...

RIPAFRATTA: I've had enough of this. (*To COUNT.*) Next time, I'll bring my own sword. (*He tosses the broken sword away.*)

MARQUESS: Hey! That hilt cost money.

MIRANDOLINA: You can't go yet – your reputation's at stake. These gentlemen think you're in love. You've got to prove to them that you're not.

RIPAFRATTA: Why should I?

MIRANDOLINA: It won't take a minute. (*To MARQUESS / COUNT.*) What's the surest sign of love? Jealousy. If he was in love with me, he wouldn't let another man go near me – and as for marrying me...

RIPAFRATTA: MARRYING! (*Beat.*) Who are you marrying?
MIRANDOLINA: The man my father chose – who else?
FABRIZIO: Er – that wouldn't be me, by any chance…?
MIRANDOLINA: Of course, dear. And these gentlemen can be witnesses.
RIPAFRATTA: I don't believe it.
MARQUESS: Him!
RIPAFRATTA: This is intolerable.
COUNT: (*With a gleeful look at RIPAFRATTA.*) An excellent choice! Can I offer you a dowry? Shall we say three hundred crowns? As my peasants are always reminding me, an egg today is worth a hen tomorrow. If you marry him now you can have a hundred up front. Any objections?
(*This is aimed at the MARQUESS, who makes a sheepish gesture and says nothing.*)
MIRANDOLINA: That's good of you, but I don't need a dowry. What am I, after all? A poor woman with no style and less charm – I could never get a man like you – (*Meaning COUNT.*) or you – (*Meaning MARQUESS.*) or you. (*Meaning RIPAFRATTA.*)
FABRIZIO: Thanks!
(*MIRANDOLINA winks at FABRIZIO, unseen by the others.*)
RIPAFRATTA: Marry who you damn well like. You tricked me – made a laughing stock of me – and it seems you're actually proud of it. You want to test me to the limit, don't you? God knows, I ought to repay your treachery with a fist in the face. No, I should tear your heart out and exhibit it in public, as evidence of female duplicity. But I'd only be demeaning myself further. I've had a revelation. I see now that it's not enough to detest women. One has to…
MIRANDOLINA: (*Coming up to him, with a final seductive flourish.*) Yeees?
RIPAFRATTA: Avoid them all together! (*Rushes out.*)
COUNT: What a hypocrite.
MARQUESS: No breeding, you see. I could see that, the first time we met.

MIRANDOLINA: Keep your voice down! There's no telling what he might do now – and I've been through quite enough as it is. (*To FABRIZIO.*) Fabrizio, my love – come here. Give me you hand.
FABRIZIO: Now, just hang on a minute! You go around seducing misogynists, and then expect me to marry you at the drop of a hat!
MIRANDOLINA: Don't be an idiot. It was a game. And games are all very well for an independent woman – but it's a different story once she's married.
FABRIZIO: It is? In what way?
(*Enter RIPAFRATTA's SERVANT.*)
SERVANT: Miss Mirandolina... I had to see you before I left.
MIRANDOLINA: You're going?
SERVANT: Yes. My master's seeing to the horses now. I'm to join him with the luggage. We're setting out for Livorno immediately.
MIRANDOLINA: Look – I'm sorry if I haven't been...
SERVANT: I'm afraid I can't stop. But thank you, and goodbye.
(*He bows low and exits; FABRIZIO shoots him a brief, suspicious glance – then dismisses the idea.*)
MIRANDOLINA: That's that, then.
COUNT: Mirandolina – married or single, I'll always be there if you need me.
MARQUESS: That goes for me, too.
MIRANDOLINA: You're very kind, both of you. But I've got a husband now: I shan't need admirers, or presents. I've always pleased myself, you see – sometimes at other people's expense. I've even risked my reputation now and then. But not any more.
FABRIZIO: Now, just a...
MIRANDOLINA: What's wrong? Give me your hand.
FABRIZIO: I want something in writing.
MIRANDOLINA: Don't be ridiculous. (*Thatcher.*) GIVE ME YOUR HAND!
FABRIZIO: Alright, alright – here it is! But...

MIRANDOLINA: (*Softening.*) But me no buts, please. I'm yours now, and you'll just have to put up with it!
FABRIZIO: I give in.
(*MIRANDOLINA rolls her eyes at the audience.*)
COUNT: Mirandolina, you're a great woman – men are putty in your hands.
MARQUESS: What can we do for you?
COUNT: Just name it.
MIRANDOLINA: Alright…
FABRIZIO: (*Aside.*) What's she after now?
MIRANDOLINA: …find yourselves another inn.
COUNT: That's an excellent idea. I'm leaving now. But I'll never forget you.
MARQUESS: Ehem – you wouldn't be missing a gold flask, by any chance?
MIRANDOLINA: As a matter of fact, I am.
MARQUESS: Here it is. (*Hands it over.*) I – er – found it lying about. (*Very formal.*) I, too, shall be leaving tonight. But I can assure you that, wherever you happen to find yourself in the future, you can rely on my pro–
FABRIZIO: Oh, leave it out!
MIRANDOLINA: (*Courteously, to COUNT and MARQUESS.*) No really – I appreciate your kindness. But you must understand, I can't go on as before. What's more, you've both learned a useful lesson. Perhaps you won't be quite so susceptible in future. If you're ever in any doubt as to whether you should give in or hold out, just remember what you went through here – remember Mirandolina.

The End.